(Previous page)

**Stass at the
Cyprus College
of Art**
1999

PUBLISHERS' ACKNOWLEDGEMENTS

The Orage Press would like to thank the
numerous people involved in the production of
this book, and in particular the collectors who
gave permission for Stass's work to be
photographed, including Maria and Savvas
Adamides, Margaret and Petkios Georgiades
and Marianna Liven, as well as the other
private collectors who wish to remain
anonymous.

Particular thanks go to Christos Ktorides who
assisted in the photography of the many
artworks from his collection that are
reproduced in this book.

Thanks also go to the public and corporate
collections that permitted the reproduction of
works in their collections, including the Arts
Council of England, City of Leeds Museums
and Art Galleries, the University of Leeds Art
Gallery, Laiki Bank, Bank of Cyprus and the
Cyprus State Collection of Contemporary
Cypriot Art.

In addition we are grateful to Benedict Read,
Tom Lynton, Mary Paraskos, Margaret
Paraskos, Christopher Paraskos, Michael
Paraskos, Emma Hardy, Hilary Diaper, Dennis
Chong and Sylvia Thompson, and to the
Cyprus Ministry of Education and Culture
for giving their time and assistance.

This publication has been co-funded by the
Orage Press, the Leeds Philosophical and
Literary Society and Cyprus College of Art.

TITLE
Stass Paraskos

AUTHOR
Norbert Lynton

PUBLISHER
The Orage Press
16a Heaton Road, Mitcham, Surrey CR4 2BU

ISBN
0 954 45230 5

PRINT
Cherryprint, 3 Tadman Street, Wakefield,
Yorkshire WF1 5QU

DESIGN
Tom Lynton
www.tomlynton.com

Distributed in Cyprus by
Moufflon Bookshop, Nicosia

THE **ORAGE** PRESS

First published in Great Britain in 2003 by
the Orage Press. © 2003 The Orage Press.

Stass Paraskos
Norbert Lynton

Part of the Great
Wall of Lempa
2001

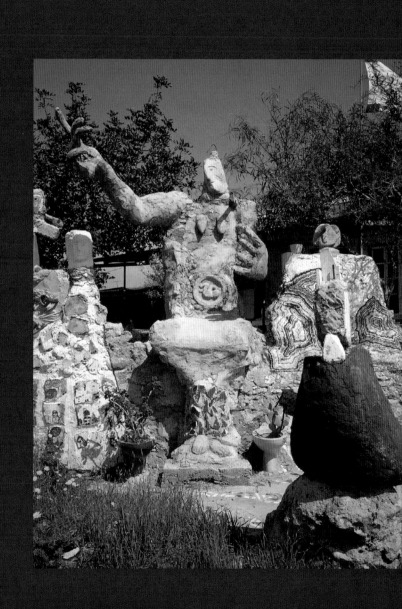

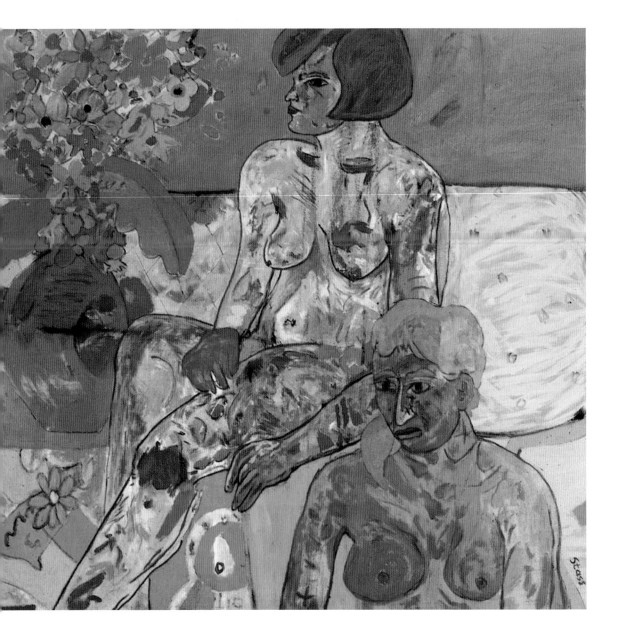

His parents called him Stassinos, after ancient Cyprus's renowned epic poet. It was his fellow students at Leeds College of Art who trimmed his name down to Stass in the 1950s, and this became the artist's name, the name he signs his work with. But of course he is also Stass Paraskos, his official name, and this hints at a duality we shall need to watch out for. It is my impression that, as an artist, he likes to be thought a simple man, one who grew to manhood in the fields and was taught to sing, so to speak, by the birds. But he is also a thinking man, a Greek Cypriot dismayed by the continuing division of his homeland, as well as, more generally and internationally, the insistence of leaders, in politics and religion, to get things wrong. And 'wrong' here means not in the longterm interests of humanity. A profound romantic, Stass is also a hard-thinking, articulate citizen of the world.

'Stass', at any rate, is the name I got to know him by in those early years: I was teaching art history at the College; I was also close to its remarkable group of innovatory teachers, and thus a daily visitor to the studios. It was a great period of learning for me. For Stass too. He was a relatively mature student there and he stood out partly because of this, partly because of his gentle ways and funny English, but mostly because there was something very special about his painting and drawing: energetic, sometimes passionate, sometimes lyrical, at once personal and bearing traces of his admiration for Mediterranean traditions and Modernist priorities that surfaced after Impressionism. He was a star pupil; a quiet, hard-working star, not one to swan about in search of approval. Yet approval is what he got from his far-sighted tutors, and from his fellow students who sensed his strength.

The name Stass symbolizes aspects of his particular quality. An ancient name, a poet's name, shortened to fit modern informality. A name rooted in Greek civilization but sounding a name new in the twenty-first century. The long name suggests Cyprus; the short form of it could come from anywhere. He could have led a

Clea and Justine

oil on canvas

1966

Stass drawing

c 1963

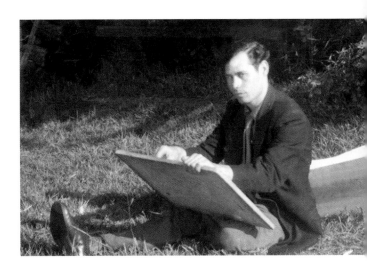

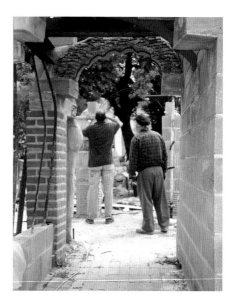

pop group with it. As a signature it is neat and clear, not overbearing the way many painters' signatures are. Stass's art belongs to Cyprus, and to successive Greek traditions, and acknowledges these roots: at the same time it is international and modern. In its subject matter it ranges from the private and personal realm of love and family, via the shared intensity of ancient myths, to contemporary issues, grave – most obviously mankind's remarkable skill at finding reasons for mutual annihilation – and not grave – most obviously his many paintings commenting on the loveliness and absurdity of human beings: lovers, friends, parading beauty queens and those recurring seven-day wonders, the tourists and the amusement with which the native population of Cyprus gazes at them.

**Disappointment
oil on wood
1966**

He has written about his life for this book. He tells us of his peasant origins in Larnaka District, of his little-schooled Father and wholly unschooled Mother who struggled to make sure their six boys would be better educated than themselves and attain more eminent roles in the world. The boys all came to England, one way and another, Stass to wash up in Lyons' Corner House and observe the Bohemian life of Soho, and then to Leeds where he had relatives and could work as a waiter. Then also to the College of Art as a part-timer. It seems that a waitress he knew worked also at the College as a model; through her he became aware of art and of his desire for it. He had worked, before coming to England, as an apprentice at a

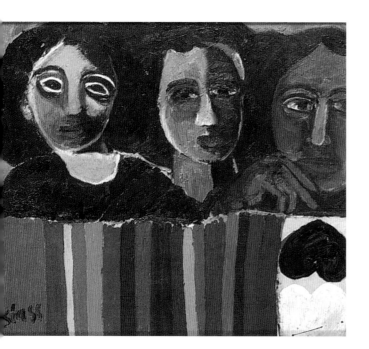

printing works in Nicosia, learning something of graphic design and forming critical judgments of contemporary images such as posters. He had always written poetry, from his school days on, so he had tasted the exhilaration and pains of creative work, but the thought of being an artist himself was new and unexpected. Was entering the Leeds College the miraculous turning-point? Not exactly. He found himself being taught drawing by Mr Helps (we all knew him as 'Mr Helps'), a caring, sincere gentleman who knew that there was only one sort of drawing and that it had been perfected by Raphael. Drawing, according to that tradition, was either right or wrong. It meant squeezing oneself into a uniform of style and aspiration that Stass found he could not possibly don.

One wonders how Stass would have continued. Then came Harry Thubron's appointment as Head of Fine Art at the College in 1956. His name resonates in Britain to this day: a fine, inventive, often subtle and delicate, sometimes ruthless artist who was also the greatest reforming art teacher of his time. His influence throughout Britain and beyond has been extraordinary, but not always entirely in his spirit. It is difficult to summarize his contribution, since he demanded both freedom and discipline. Others, having enjoyed some brief contact with Harry (everyone called him Harry; this informality

Part of the Great Wall of Lempa

was suprising in those days but is symbolic of his understanding of his role), and been excited by the experience, decided that he had a system; they called it the Basic Course and assumed it had been derived from the Bauhaus of the 1920s (of which, in fact, very little was known in the 1950s). Harry collaborated

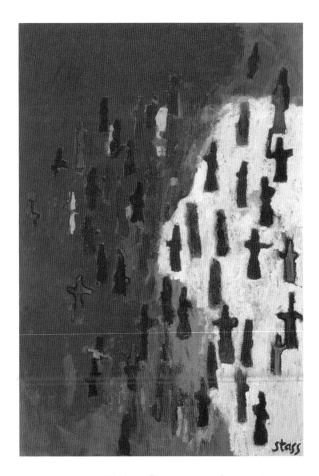

On the Beach

oil on wood

1967

with Victor Pasmore on a few short courses offered during the vacations, open to all, professionals and amateurs, but demanding concentrated effort from everyone. Also, Harry brought remarkable individuals to Leeds to work with him in the College, notably Tom Hudson, a painter and sculptor who had already done outstanding work with schoolchildren and was deeply committed to developing new methods in art education at all levels. (And Harry brought me into the College to teach art history and to create a proper library, and thus I found myself, a certified art historian, discovering not just modern art but art itself as a magical, ever-refreshing human activity. I attended some of the short courses, summer schools and winter schools, hoping to understand better what was going on).

Harry recognised the poet in Stass as well as his innate talent for drawing and painting, and only asked him to work and work and work, to follow his nose but also, always, to learn from the work itself as it progressed. He made his colleagues aware of Stass's special status in the studio: he did not want Stass interfered with. Stass's fellow students sensed this too. To this day they speak of Stass painting away in his corner of the studio, set a little apart from themselves but admired and held in real affection. At the same time, Stass was exposed to the knowledge and enthusiasms that were developing in the College of Art, in touch with what his fellow students were doing and what was being said to them, and learning more through conversation, lectures, visits to exhibitions in and outside Leeds, and access to a suddenly developing library of art books and periodicals. No one there put a romantic value on ignorance: seeing should be fresh but knowledge of the best art available was essential. Harry would then have given priority to Van Gogh (always referred to as 'Vincent'), Matisse, whose status was at last established by the exhibitions that followed his death in 1954, and Paul Klee. Harry admired Klee both for his conviction that the best art grew out of

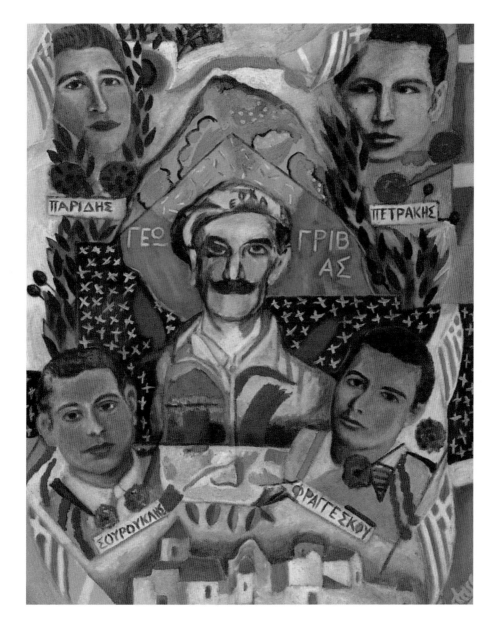

Folk Motif

Oil on canvas

1991

intense collaboration with the elements and processes of art, and for the delicacy with which he pursued his wide-ranging work. Stass learnt that he was a contributing member of an ever-changing art world, just as these modern masters were and their work is.

The experience of being encouraged to develop his work without being given restrictive orders, of finding himself and his paintings valued, and of existing in this context of enquiry and enthusiasm, as well as of quite tough criticism – Harry could be quite harsh if he felt students needed focusing or energizing – was the best possible professional base. Harry was generous with his praise for good work, and delighted particularly in the unintended discoveries that could happen when a student pursued a particular idea with full concentration. Art is not a hobby or a polite social accomplishment: it is work that engages the entire individual and demands unremitting attention. But be alert, Harry taught, and you will encounter magic as you work.

Art schools were not supposed to accept as students men and women who had not passed certain grades at school, and Stass studied hard to get some of the required basic entrance qualifications. But Leeds College of Art was allowed by an exceptionally liberal local education authority to accept not fully qualified students as

Part of the Great Wall of Lempa

special cases. Not only did Stass work in the College for four years as a student, but he was invited to do some teaching, in Leeds and then also in other art schools. Out of this growing experience of teaching, and out of his enduring love of Cyprus, came the idea of starting an art school in Cyprus, a place to which maturing painters would come from anywhere in the world, at first for summer schools during which they could develop their work in a new situation and in contact with tutors and fellow students, and then also a college that could offer year-round studio space and tutoring. The Cyprus College of Art, which started in Famagusta in 1969, moved to Paphos in 1972 and found larger accommodation in near-by Lempa in 1978. From then on, it has offered space for post-graduate artists as well as open summer schools. Stass and his College were and are fortunate to

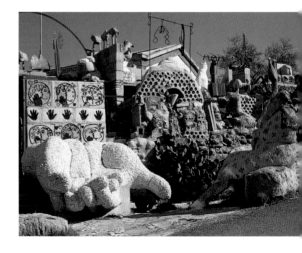

have the interest and support of the Cypriot Ministry of Education. As an island set into the eastern Mediterranean, where European civilization was born and grew, but close to Asia and not far from Egypt, Cyprus can be a world centre. What Stass wanted to offer was both the local experience in a particular, rich cultural context and what he calls 'a window to the world'.

It is difficult to guess at the talent and zeal that took Stass from tending sheep to creating and leading Cyprus's first art school, and to being the deeply rewarding painter he is. To see him at the College is to become aware of his quiet authority and the students' respect for him. Stass has brought significant artists from Britain and other countries as visiting tutors – Terry Frost (now Sir Terry) is a major example – and in addition he has highly regarded painters visiting the College for substantial periods in order to pursue their work away from home – for example, the late Euan Uglow. The mix of personalities and abilities, of backgrounds and ages as well as stylistic intentions, results in a healthy, mobile situation in which art can thrive. The College itself, the physical environment, has changed over the years without ever turning itself into a bureaucratic straitjacket. Of this the Wall surrounding the College assures us, as it develops and grows into an amazing, permanent but also ever-changing collaborative work. More about this later.

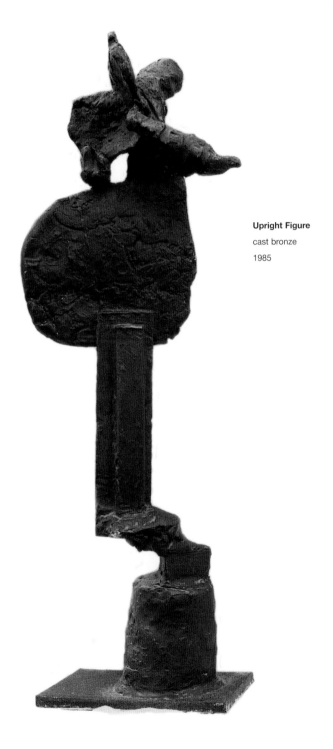

Upright Figure
cast bronze
1985

**Lovers and
Romances**
oil on board
1966

Stass's paintings have developed over the years, in manner and in content, though their essential character, which is also his, remains constant. I nearly wrote 'and in ambition', but from the first he has produced 'simple' still lifes and figure subjects as well as occasional paintings that tackle more polemical subjects, often on a larger scale. Stylistically, it seems to me, he has moved quite rapidly from a relatively graphic idiom to one that is wholly painterly. I mean by this that in the earlier work, until the early 1970s, he was drawing lines with the brush and filling forms in as and where he needed them, but leaving the picture quite light, usually with a white or pale ground. From the mid-1970s on he has painted more fullbloodedly, producing pictures full of colour – sometimes also quite dark paintings (which are difficult to reproduce effectively) – and altogether developing a pictorial idiom that can communicate lyrically but, when required, also dramatically to deliver grave themes. Much of his art comments affectionately on humanity's ordinary ways in its everyday doings.

St Ives

oil on canvas

1959

When Stass had his 1966 solo exhibition at the Leeds Institute, up a steep staircase, in a room occasionally used for exhibitions, one of his graphic paintings, entitled *Lovers and Romances*, and a drawing related to it caused a great rumpus. They are small, undramatic images about love. In their bottom left-hand corners they show a man and a woman, naked, more outlined than painted, without emphasis on the two bodies as physical objects. She is seated across his lap. We can make out two lines that may signal the first inch of the man's penis. They are kissing; there is no indication of further sexual action.

These are light and lyrical pictures, romantic rather than sensual.

Two schoolgirls had been heard giggling. Someone alarmed the Leeds police. Technically speaking this was a public display, though very much inside the Institute and for the College of Art around the corner. The police seized the offending works, and Stass was accused, under the Vagrancy Acts of 1824 and 1838 of 'publishing an obscenity'. (The question whether it was not the College that was actually guilty of 'publishing' this art was never asked. Easier to go for the individual.)

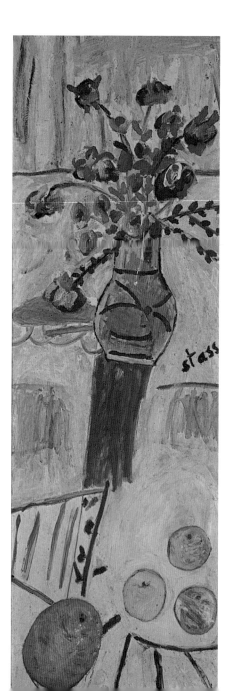

Still Life
oil on canvas
1960

The trial must have been a painful experience for him: a strange situation in a strange country. Today we are all more relaxed about these things, and the accused might well be heroicized by the media. Even then, the press, reporting the trial, seemed surprised at the fuss: would this prosecution have happened in London? The trial took place before three magistrates. For two days, people called as 'expert witnesses' by the defence spoke up for the quality and inoffensiveness of the pictures: Sir Herbert Read, the world-famous poet, art critic and educationalist; Professor Quentin Bell of the Fine Art Department of Leeds University, artist and author as well as critic; John Jones, artist and film-maker, who worked with Quentin Bell; myself, by then head of art history at Chelsea School of Art in London and *The Guardian's* art critic. We did our best to sound reasonable. I recall being asked what I would think if I 'saw this kind of thing going on in the street outside', and tried to explain that poetry and art were not the same sort of reality as daily life – that, for instance, when we were hungry we might go to a café or a restaurant but certainly not into an art gallery to feast on a still life. What if we saw a man being crucified in the street? It was all a waste of time. 'Mr Paraskos' was found guilty. It was said the pictures would be destroyed, but in fact they were returned to him and a fine was

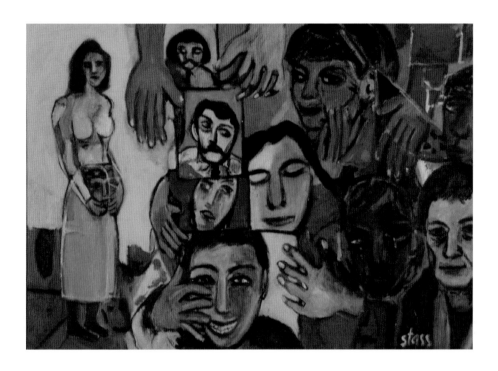

Mothers of Missing Persons, No. 1
Oil on canvas
2001

imposed. Not too grave a matter? It lives on in Stass's mind.

The most immediate consequence was two-fold. The head of the College, Eric Taylor, arranged for Stass to be given part-time teaching: two days a week. Stass had already, since 1963, been teaching under Tom Hudson at the Leicester School of Art. To be teaching in, so to speak, his own College was an additional confirmation of respect, especially after that prosecution. The other consequence of the trial was that

there was talk in London of raising the question of obscenity laws as relating to this instance in Parliament. No one thought them effective or satisfactory (they have been amended since, but the situation remains unsatisfactory, as it must in a such private-public matters where people generally want freedom for themselves but often seem to feel that others need the protection of censorship). Stass received letters from the Home Office, signed by the eminent politician Tom Driberg, who was writing on behalf of the even more eminent Roy

Jenkins (the late Lord Jenkins, then Home Office Minister in Harold Wilson's government). They expressed sympathy for Stass; this would not happen again, and if Stass cared to let the Home Office know when he was next exhibiting work in London, the Minister would make a point of coming to see it and bring with him Jennie Lee, the admirable Labour Member of Parliament who was Minister for the Arts. The United Kingdom has a gift for fudging issues where morality and law conflict, but this unambiguous encouragement – implying, if not actually stating, disagreement with the court's decision – was both bold and admirable.

Terry Frost was the Gregory Fellow in Painting at Leeds University during 1954-6 and got involved with the Leeds College of Art, teaching there for three years after the Fellowship ended. He encouraged Stass to spend some time in St Ives where Frost was a leading member of the so-called St Ives School of artists which included Ben Nicholson, Barbara Hepworth, Patrick Heron, Roger Hilton, Peter Lanyon and other notable individuals. Most of them were producing abstract art, or art much abstracted from visual reality, often in expressive idioms which reflected the space, colours and dynamics of the Cornish land- and seascape. Just as Frost's work was affected by his experience of Yorkshire, so Stass's was enriched by what he

found among the St Ives artists, but a major by-product of these visits to South-West England and that busy creative scene was that Stass could know himself as one of them, with his own character, priorities and ideals, but unquestionably part of an active, disputatious as well as often positively friendly, world of living artists. His work gained in strength. He had close on twenty solo exhibitions in the 1960s, and he was sought after as a teacher, even becoming Senior Lecturer in Painting at the Canterbury College, later Kent Institute of Art. To this day, Stass is welcome as a visiting tutor at a number of British art schools.

Love
oil on canvas
1979

Sculpture at the Cyprus College of Art
2001

**The Garden of
Eden (Temptation)**
oil on canvas
1997

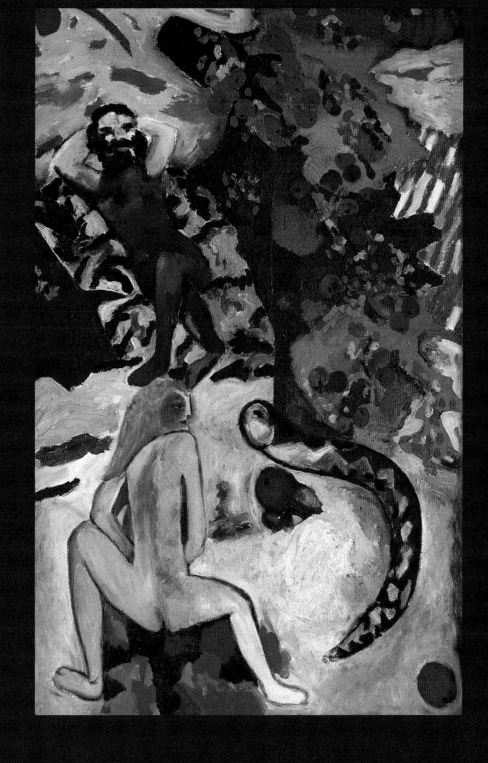

Stass said to me, in June 2002: 'I enjoy playing a reactionary role. I like old-fashioned subjects'. Stass has never made abstract paintings, but none of his work is merely naturalistic and descriptive. As others have pointed out, his master – a key figure for him in the way that Raphael was the essential master for Mr Helps and other academics for centuries – was Gauguin. Gauguin, after being an amateur Impressionist, became art's great liberator. He detached art from the age-old task of representing the visual world more or less directly. He abstracted forms, including those of human beings; he heightened and poeticized colour; he mingled representational figuration with super-real settings that are most easily understood as a sort of visual music; he took ideas from so-called primitive cultures and even re-invented himself as a conscious primitive by going to live and work in the South Seas. He learned to express his thoughts and emotions through paintings, sculptures and graphic work that often derived from the scenes around him but were transformed into dramatic, essentially visionary tableaux relating his dreams, visions and fears. He set aside the perspective and tonal modelling demanded by classicism and realism, and moved so far from inherited principles of representational art that his work is rightly associated with the innovative, but often also essentially spiritualizing, transcendental literary movement, Symbolism and its adjunct developments in music and art. It has been argued that a great deal of modern art is part of a widening Symbolism.

Stass is certainly a Symbolist in this broad sense. He came to art a little late, as did Gauguin, and has become an artist embracing the traditions of Cypriot art, which are primarily those of the Byzantine world of Orthodox Christianity, but also the Greek inheritance, of image as well as literary material, that belongs to the eastern Mediterranean. By studying and working in England for many years, in a situation which did not prescribe any particular

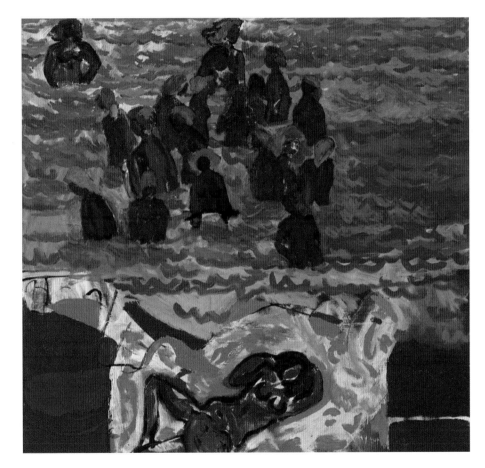

Bathing

oil on hardboard

1968

artistic method or language to him, he could find his feet in those parts of the European tradition that stemmed from Gauguin, Van Gogh and Post-Impressionism, and then also add a particular awareness of Chagall and Matisse. Matisse was and always remained essentially a French artist, though one exceptionally alert to the values of Islamic art as well as to Orthodox icon painting. Chagall, marginalized in Russia as a Jew, developed a sort of personal folk-art idiom before visiting Paris and making contact with Cubism. Back in Russia, he welcomed some of the radical art forms that became public after the

1917 Revolution, but by 1923 was back in France. Chagall worked in many European and Near-Eastern countries as well as in the USA, always returning to France. Matisse worked only in France, though he got commissions from Moscow and his early collectors were mostly Russian and American. He was middleclass, but experienced hardship if not extreme poverty. Chagall, of very simple Jewish origins, and needing special sponsorship to be allowed to study in Petersburg, became famous and wealthy but never lost touch with his *Stetl* roots. Sometimes we can find his art too sweet, too adolescent in its dreaming, but much of it is intensely poetic in strong and original ways, whether he is dealing with eternal themes such as life and death or celebrating the Russian dream of creating a new and more humane world.

Consider Stass, with his simple origins, sweetly pastoral to our metropolitan minds, but harsh in reality. One thinks of D.H. Lawrence as an English and urban equivalent, a coal miner's son, led into education by his mother's ambition for

Hesitation and Agony
oil on canvas
1979

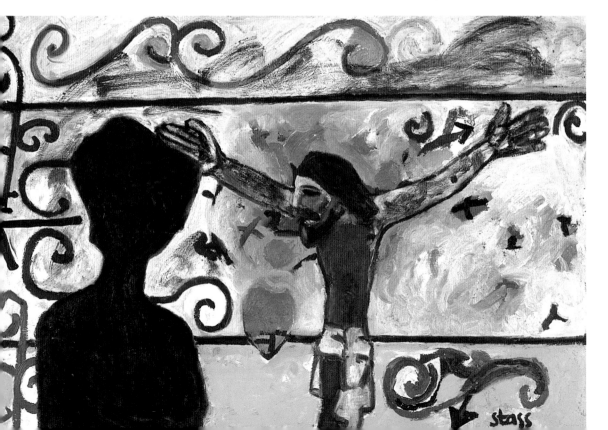

Job's Comforters
oil on board
1988

him, and becoming one of the greatest novelists of the twentieth century. Stass's mother made her sons get what education was available, and made sure they knew its importance. She wanted them to make their way in the world. In his time Lawrence was as much notorious as he was famous; even those who knew and admired him, the intelligentsia of his day, never felt comfortable with him. But then he challenged the world by insisting on opening up social, often sexual, issues that polite societies wanted not to face: he was in rebellion against upper-class conventions, and against the industrialization that seemed to reinforce them while strangling man's natural desires. A London exhibition of his paintings was closed by the police in 1929, and Lawrence wrote *Pornography and Obscenity* the same year. He considered western society 'castrated'; his pictures, his novels and his stories preached a truer relationship with man's nature, spiritual as well as physical. A Midlands' Englishman, often in London, but spending much of his time abroad (in Italy, New Mexico etc.), he seemed an outsider as well as an un-clubbable eccentric to those who might have been his professional colleagues.

Stass is not a demagogue, but he has his view of the world and delivers his opinions through his art and writings, as well as his teaching. He is a man of books, reading

ceaselessly, thoughtful, discussing. He is keenly aware of public affairs. He has inherited a rich past; he lives amid cultural stirrings that refer to this past in various ways and reach out, sometimes courageously, to the global cultural situation of the present. He is frequently in England, though his proper home is now in Cyprus. He exhibits widely, in Britain (including at the prestigious Institute of Contemporary Arts in London) as well as in Cyprus and Greece, but he has also shown in New York, in Brazil, at the 1996 São Paulo Bienal and in Denmark.

There are dangers as well as opportunities in the attempt to fuse, or build bridges between, advanced western art – the publicized art of Europe and America – and the cultural traditions of other countries, whether this means Israel, India, China, Cyprus or wherever. The desire to join in the West's well-promoted, star-studded and sometimes also admirable modern artistic adventures is well understood: it can bring intellectual as well as material rewards at home and implies the possibility of an

Mysterious
Meeting
gouache
1993

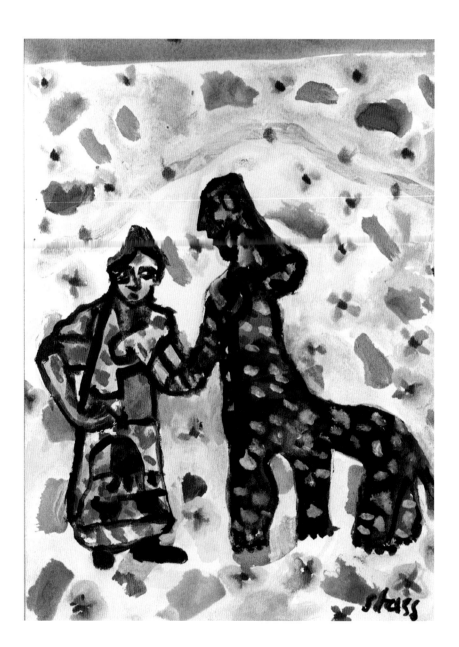

international career. Too often, though, something like a trick is involved, a forced marriage between an imported style or technique and recognisable local motifs and idioms. Knowing western ways well enough to be able to adopt them without falsification requires exploring them below their superficial features, their styles, and connecting with the motivation driving them, without surrendering one's own personal and native roots. Connecting with and taking from other artists plays significant roles in every serious artist's work. To do so can highlight meaning or give particular expression to part of a picture, and to introduce a strange element into one's art creates particular visual tensions in it, just as does incorporating recognisable found objects in a sculpture.[1]

Stass discovered art in England, and in a uniquely favourable and spirited context. He had of course absorbed something of the artistic as well as literary legacy of Cyprus before he came here, especially the solemn church art of the Byzantine tradition. This in itself prepared him to discover Gauguin and Matisse. He had nothing to unlearn in the way of contemporary art practice and no immature attachments he would need to shed. He was encouraged to discover himself as an artist, without preconceptions. He benefited from the guidance and stimulus of mature, open-minded artists and from the environment of hard-working students.

Today he is a quietly confident artist. His work is exhibited frequently, and sought by a growing number of collectors, individual and institutional. It is assured work, by no means monotonous in subject matter or manner. Though it has characteristics which one learns to enjoy and recognize, it does not parade a brand-image. Even a brief survey of what he has produced proves this, whilst also revealing the constants in his art that make it his, whatever the occasion or impetus behind a specific work. He paints and he draws, as he has done for more than four decades; more recently he has also made and exhibited sculpture.

Still Life

oil on wood

1965

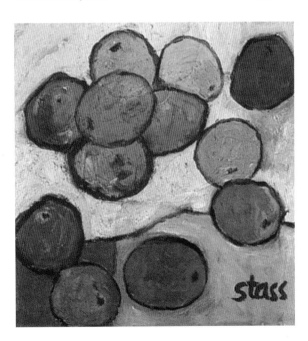

The Village
oil on canvas
1996

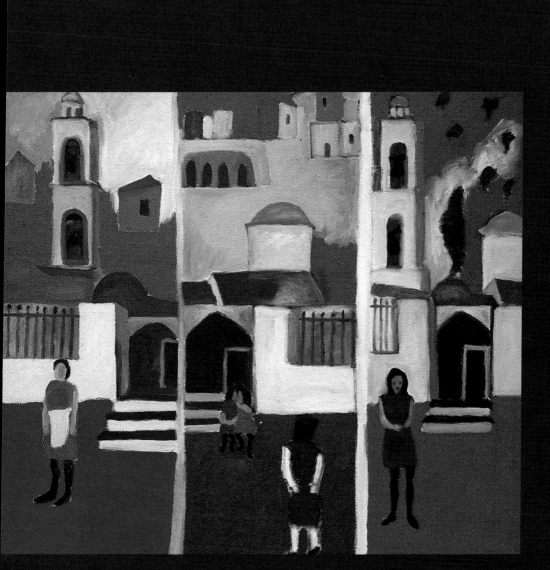

Stass has always destroyed a lot of his work. Some he has given away over the years or otherwise lost touch with. At the same time, he makes it look easy – a little like the famous anonymous child who said, 'First I think, and then I draw a line round my think'. He wants his work to look natural, impulsive. And very often it is, though experience and knowledge play a greater part than one might think at first glance. His self-criticism is revealed when we catch him reworking paintings. *Wine and Sympathy* (1990, 75 x 100 cm) is a strong painting, showing a gloomy, semi-dressed woman being comforted by a naked one. An early photograph shows he has adjusted the colours of the nude, and the head and right hand of her friend. It is one of those Stass paintings in which, in spite of their directness, their lack of academic idealisation, we sense an underlying classicism and monumentality. This was already so in the original version; as reworked it is much enhanced. Here is just one example of what is a routine questioning relationship with his art: he paints almost every day, and for long periods, following his intuition as well as the sensibilities sharpened by years of professional practice, yet he also carefully studies what he has done and rejects or alters pictures according to whether they meet his standard. But this standard is not the same thing as adherence to a type. The issue is whether the image he has made carries the meaning and the effect he was after. Some of his paintings come in series, so that he may for some time paint, say, a succession of still lifes of similar form and character. We notice their family resemblance; for him they are different ventures though into the same terrain. But generally his paintings do not come in series, and changes of subject often bring major changes of presentation, without loss of personality.

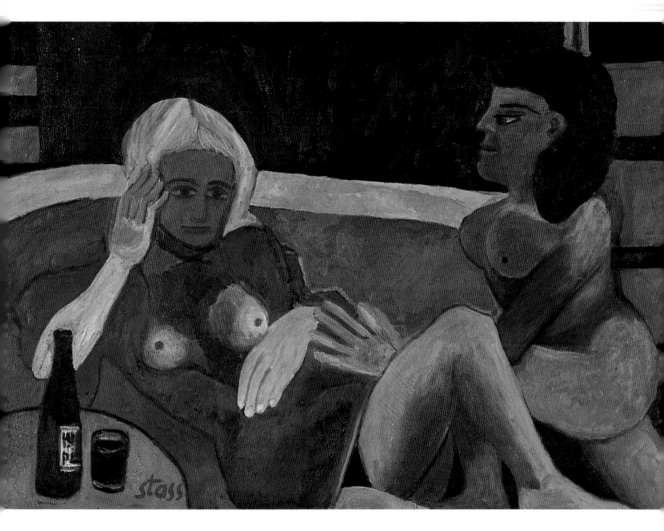

Among the first Stass paintings we know of is quite a large one he calls, simply, *St Ives* (1959, 62 x 104 cm). It has something of the graphic manner to which I referred: it uses a light ground and some of the motifs in it are rendered mostly in lines. Though there are areas (foliage, a mound, an island in a pale sea) which show him using his brush and colours freely and quite deliciously, the main effect is of dark objects (figures, arches, a pier) set against light. It is very effective, especially in conveying a complex scene without strain. I don't know where Stass learnt this; he may have developed it without outside stimulus, though I remember that Harry Thubron at times gave white the dominant role in his paintings of the 1950s and Terry Frost's abstracted Yorkshire landscapes of those years ranged from those using strong, contrasting colours to others dominated by white when they reflected on Wharfedale under snow.

Wine and Sympathy
oil on canvas
1990

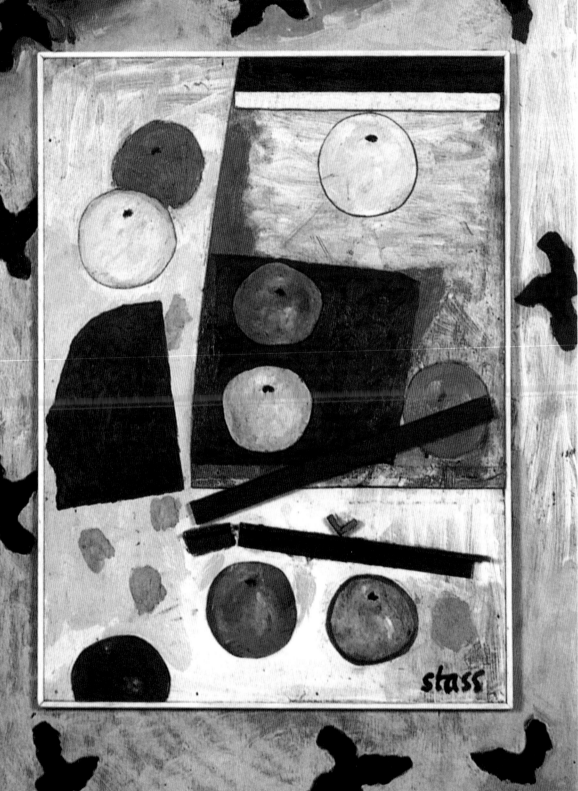

It is just possible that Stass may have come across the white paintings of the Belgian Post-Impressionist James Ensor through illustrations in books. Not many people were aware of Ensor then, but these are striking, memorable images, often sharp and disconcerting, in spite of their initial air of innocence. Something of this character always underlies Stass's art: he wants us to meet it without too much learning and receive it as instinctive, almost primitive statements. At the same time, the more we know of it, the more we have to accept that Stass is a well-informed painter who knows where he can draw support from other artists. One of his early paintings is actually entitled *Homage to Ben Nicholson* (1962, 88 x 64 cm). It does distantly resemble both a still life by Nicholson, the leading and best-known painter of St Ives whom Stass in fact never met (Nicholson left St Ives in 1958), and his abstract compositions. It is also a constructed work, in that he has mounted a smaller painting, within its simple frame, on a larger board which adds a decorative painted surround. Moreover, there are collage elements, two and three dimensional, in the inner picture. These details work against the Nicholson connection (he hardly ever used collage, and when he worked three-dimensionally he cut or built-up shallow planes rather than adding isolated projecting elements). The painted margin brings this picture closer to Matisse who sometimes made

highly effective use of this device in emulation of Islamic carpets. In doing so he was, of course, confirming that, as Gauguin's major disciple Maurice Denis wrote in 1890, 'a painting …is essentially a flat surface covered with colours arranged in a certain order'.

Ensor's whiteish paintings are called to mind also by two other early Stasses, *Still Life* and *Still Life with Skull* (both 1960, 100 x 30 cm and 100 x 33 cm respectively). The first of these uses the tall format as one area (though there is a hint of a dividing line halfway up): apples and an orange in the lower half, the orange large and pushed close to us to give this generally quite flat painting a hint of space and of one tabletop seen from the bottom edge of the picture almost to the top, where an unemphatic horizontal line suggests the far edge of the table and a change of plane to the wall beyond it. The off-white ground colour, for both surfaces, and a number of blue and blue-green areas and touches, make this a slightly chilling, Ensor-like, image, though the fruit and the flowers are friendly enough. *Still Life with Skull* is more dramatic. We see in it four, possibly five, distinct areas, stacked above each other to deny any sense of recession. Fruits can be glimpsed in all of them, and are dominant here and there. In the middle section, apples on a striped tablecloth are joined by two pots of flowers. The

Homage to Ben Nicholson
mixed media
1962

35

Still Life with Skull
oil on board
1960

most prominent object in the picture is also the most alarming and unexpected: the skull. This is presented fairly naturalistically, in profile, in the bottom section, a pink-brown representation against a blue ground. Since medieval times – but not in Greco-Roman culture – a skull has been used in art to remind us of mortality, sometimes amid objects celebrating life's pleasures. Ensor painted several macabre images of skeletons and other horrors, both out of personal inclination and in response to the annual Carnival processions of his native Belgium, when ghastly as well as amusing spectacles were paraded to mark the end of self-indulgence and the start of Lent and fasting.

Two landscapes of 1962 continue the use of the off-white ground over relatively large surfaces: each measures 70 x 140 cm, a double square. One, which Stass retouched in October 1964 (the date shown on the picture), is called *Shepherd* and includes a standing figure, perhaps the young Stassinos,

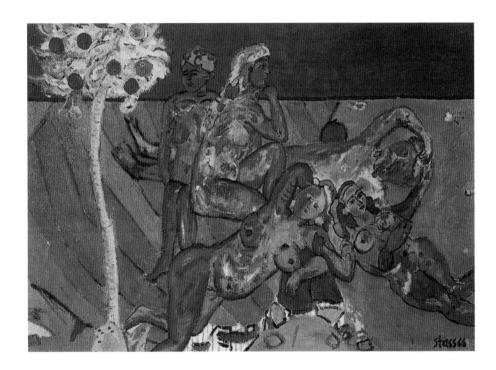

Another World

oil on canvas

1966

among a flock of sheep in the left half of the painting. The rest is trees, hills, a village – and, beyond them, the sea and two fishing boats. The relative sizes of trees and buildings, and their placing, gives this a high degree of recession, emphasized further by the sudden blue of the sea at the top. The other painting, called merely *Landscape*, has this whiteish ground all over, but onto it Stass has drawn and painted a crowd of forms and objects, some of them immediately read as houses, trees, and mountains, others less specific. The effect is curiously dreamlike. What recession is announced by the relative sizes of the buildings and by the successive lines of the mountains, is countered by the continuing pale ground. *Another World* (1966) is painted on a canvas which, at 68 x 106 cm, comes close to the Golden Section in proportion. This too is dreamlike, though here it is the subject that, we must presume, is fanciful rather than realistic. We see an interior. A naked man – the painter himself? – lies there in the company of four naked women, two lying, two sitting. All is

peace and good cheer; a still life of bodies in classical poses, painted mostly in orange and red, with blue and blue-green touches for refreshment. The faces and other details still have something of Stass's graphic manner, but the painting speaks mostly through colour, above all through the opposition of the yellow-orange floor and carpet to the Indian red of the wall. These divide the picture into two horizontal bands. Across these runs the slender trunk of a fruit tree, retaining something of Ensor's pallor, but otherwise we are wholly in the post-Gauguin world of paintings as an art of colour areas. There is some sense of mass in the bodies, but the image as a whole is kept flat by those two dominant bands, running right across from edge to edge.

Sculpture Park

oil on canvas

1996

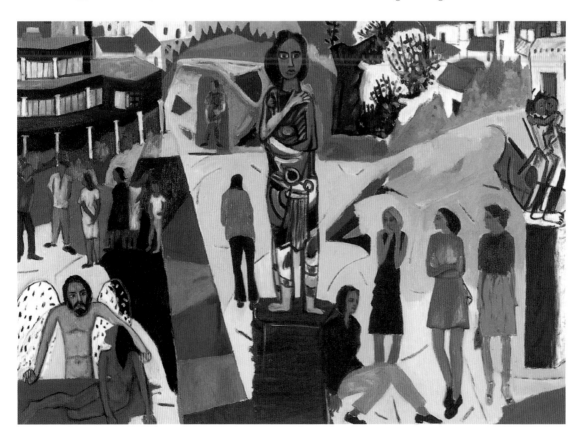

If we compare these early paintings to what Stass has been producing recently, we find an obvious growth in sophistication and power. *Red Nude* (2002) seems a simple subject, but that simplicity depends for its effectiveness on many subtleties. The figure occupies most of the double-square canvas (50 x 100 cm); were she to lie stretched out she would not fit between the left and right edges, but her knees are bent on the right, and on the left she has raised her head, seen in profile. There is much art in representing so complex, and valued, an object as a young woman's body with such economy. The torso is stretched, recalling Modigliani's fine nudes, and perhaps also Ingres's of the early

nineteenth century. She lies on a yellow/orange ground animated with red spots, and there are additional ornamental passages by her feet and above her waist. The turn and movement of the figure imply space, but the image is received as a flat design. They also give what at first seems a powerful decoration (using this difficult word in Matisse's sense) an almost startling degree of dynamism.

The *Pacification of Jenin* (2002, 80 x 100 cm) is something quite different: a dramatic assembly of heads, limbs, a coffin, a skull, a cross and various objects and instruments, some of them monstrous – as in the masked face we see first, at the bottom, centre left – but

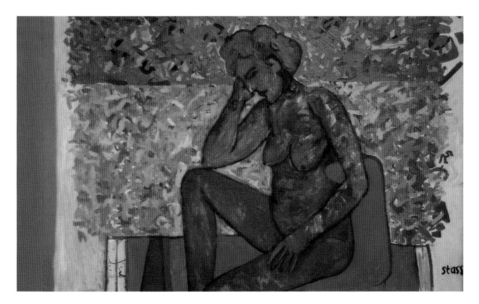

Red Woman
oil on canvas
1972

**The Murder
of Adali**

oil on canvas

1996

all ghastly by nature or by their shocked expressions. This is an entirely anti-naturalistic composition: not a story but a litany of disaster. A yellow ground unites the canvas[2]; everything else is placed on it, like collage. But we know it is all paint; we are conscious of the brush's work in conveying expression and solidity, colour contrasts as well as lines where needed. This is not a graphic image.[3] *Death of Spyro Kyprianou* (2002, 40 x 60 cm) is another kind of painting. The dead man lies at the top, across the painting, a pale image. At the bottom sit and stand two mourners, a man and a woman, linked by a decorative band that could be a carpeted seat. Between them, on a yellow ground, is a group of figures, some looking up, some down, in agitation. This is clearly a pious image, indebted to a broad tradition of religious art that includes Byzantine and Renaissance painting and possibly medieval western sculpture. The elevation of the dead man itself suggests an Assumption, and the phalanx of figures half-way up this vertical compilation recalls many a sixteenth or seventeenth-century Italian altarpiece. This is a monumental composition, though not on a large scale, supported by the architecture of the 2:3 ratio of its format.

The format evidently satisfies Stass. Other paintings of 2002 are the same

size and proportion even when they are less monumental in form and more relaxed in mood: artists and part of a large painting seen in *The Studio*; Stass and students at work in *Artists at Lempa*; artists talking and drinking together in *Artists*; two vertical canvases commenting on a modern plague in *Traffic*, where a domed church in its serenity contrasts vividly with the jumble of cars in front of it, and in *Cars and Horses* where we see cars rushing past – because of their diagonal placing – a yellow field in which three red horses graze serenely. Stass has also been painting a series of still lifes on canvases the same size, continuing a fascination with exploring the poetics of form, colour and spacing in a subject calling for relatively direct representation, a few interrelated colours and the infinite opportunities the subject offers for alternative and expressive rhythms and intervals. These new works are not wholly different from smaller still lifes Stass was painting in the 1960s, often on square boards. He was attaching himself to a tradition given new potency in the still-life paintings of Cézanne. For both painters, born almost a century apart, the touching or not touching of two apples, or the thrust of other forms such as a knife (in Cézanne) or paint brushes in a pot (Stass), are significant moments of pictorial choreography and expression.

40

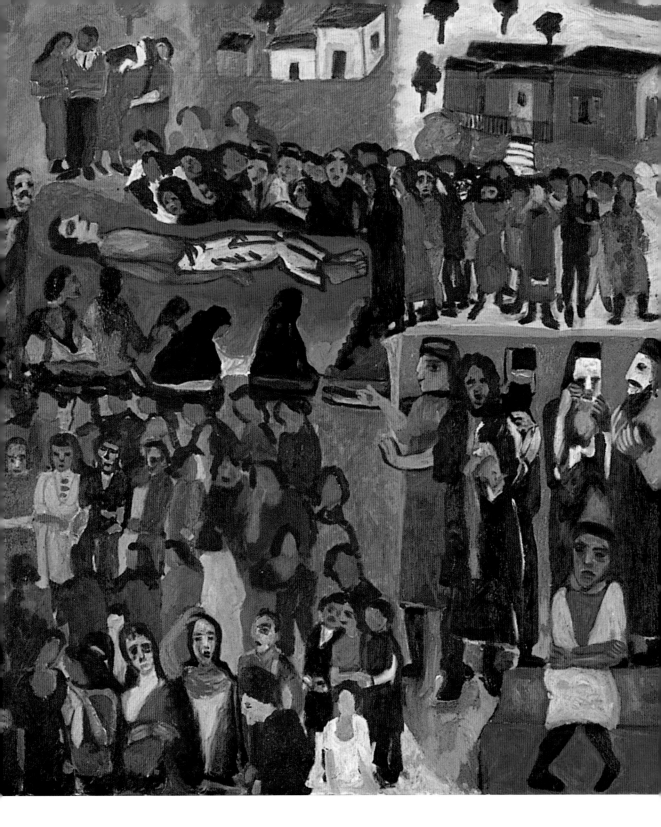

Apples and
Broken Mirror
oil on canvas
1968

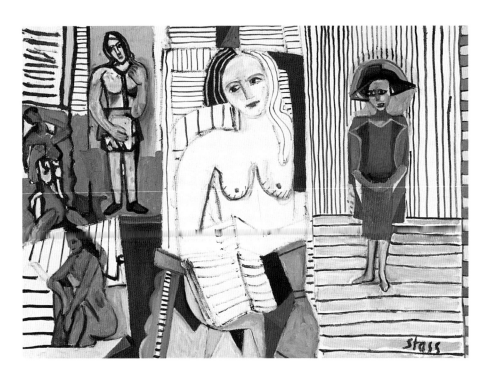

ooking at some of the different types of Stass paintings indicates the range of his work, of course, but also reveals something of his motivation and methods. That range is surprisingly wide. It is quite normal these days for painters to establish themselves in public awareness by pursuing one type of image, and often one theme. This was so with the famous Abstract Expressionists, for example, and it is true today, whether we look at the work of the most highly praised artists, say Lucian Freud, or at countless others, in and outside of the main centres of contemporary art. To some extent this has always been so: painter A would be known for his still lifes, painter B for his landscapes, painter C for portraits: they were specialists. In modern times painter X is known for his free, Impressionist style, painter Y for thick, built-up paint and signs of struggle with his images, painter Z for making handsome arrangements of stripes and patches in suave colours. But some painters, in good periods and in bad, have always reached out for a wider range of thought and expression – outstandingly so

Rembrandt. This would mean a range of styles or manners, as well as of subjects. On the other hand, Gauguin in his maturity used much the same style and limited his work to poetic transcriptions of scenes around him, or posed by him, and to more imaginative, self-expressive compositions, thus working mostly in two modes.

Stass's still lifes tend to come in batches and at intervals. I suspect he turns and returns to this subject when others do not demand his attention. They provide a kind of base, a home territory. As said already, he made a number of still lifes in his early years. He has painted a major set recently. He has made others in between. I have mentioned Cézanne as an influential precursor, but of course there have been others, not excluding Gauguin and Van Gogh, Matisse, Picasso and many another modern artist. Still life is a very real subject, and easily approached: we can all imagine setting up a group of objects and drawing and painting it; in fact, it is the amateur painter's high road into art. Stass is the opposite, entirely professional and steeped in knowledge of his profession. Still life, though it can seem natural and immediate, is a *form* of painting as well as a subject.[4] The professional artist knows this. He knows that in painting a group of objects on

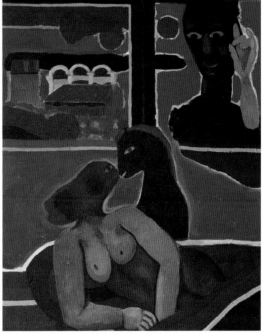

Odysseus in the Underworld
oil on canvas
1995

a table he is adding to a tradition, at once humble and glorious. He is not on his own, and even though his still lifes are clearly of his own creation, he is feeding his work into a historical network of still lifes. In a much vaguer way, we who look at art and bring with us some sort of modest memory bank of art imagery, know this and benefit from it.

Discussing his earliest paintings, I noted that already in them Stass was varying his methods, including his formats, and even, in his *Homage to Ben Nicholson*, willing to acknowledge a debt. His typical still lifes of

Still Life
oil on canvas
1960

the 1960s are quite simple. They are often on small square boards, sixty by sixty centimetres, and show a few apples of various colours on a surface that might include a rumpled tablecloth or napkin. At times, in the tradition of Gauguin, he outlines the apples individually, delicately or quite firmly. This drawing stresses their individuality but also dramatizes the action: gaps, contacts and overlappings. At times, there may bear sexual connotations. To touch or not to touch often seems to be the issue, but never the only one: groups versus single apples; brightly coloured apples versus darker ones; relative sizes. Above all, the grouping as it affects the character of the composition as a whole, even when it is quite small. On occasion, as with that *Homage...*, Stass will involve the viewer in a game, a puzzle. He has mounted a painting on a larger board, making a picture within a picture, and added collage elements to the original painting. So this becomes a still life of apples, itself on two levels of board, the smaller echoing in its formal arrangements some of Nicholson's built-up reliefs. Otherwise, the still life seems still enough, until Stass adds a rough

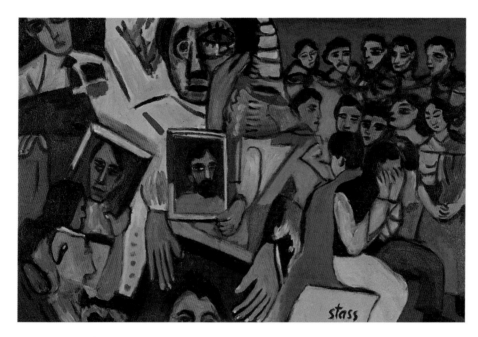

The Missing

oil on canvas

1995

patch of blue paper on the left and, more pronounced, pieces of painted wood strip to its right. There are varieties of matter and of three-dimensionality in the completed work, and one begins to wonder whether the 'homage' has not turned into a rejection. *Apples and broken mirror* (1968) seems to be a picture within a picture too: a vertical canvas (86 x 61 cm) onto the upper half of which he has imposed a smaller, almost square painting, itself divided, one third against two thirds, by a vertical line. This, presumably, is the crack in the mirror; it interrupts what we see in the supposed mirror the way cracks in mirrors do. We see apples and blobs of paint on a mottled ground of warm colours and white. The lower half represents a still life: apples clustered on the left, a looser arrangement on the right. The 'mirror' certainly does not reflect any of this; in fact the apples in the mirror are not only different in colour but larger than those below. Were they reflections, they would of course be smaller. Stass insists on playing his game by painting shadows above the inner 'picture', to hint at its solidity, and a bar with shadow below it to support it.

There are no devices of this sort, no puzzling the viewer, in his still lifes of 2002. Instead, we note a limited repertoire of still

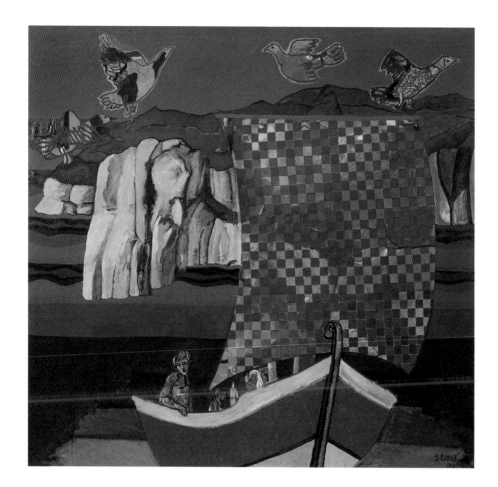

**Liberty abandons
Cyprus**
oil on canvas
1972

life objects – a mental kit, I suspect, not a set of objects set out in different arrangements for each painting: apples, some simple bowls and plates, a blue bottle, patterned or plain napkins or table cloths, and various jam jars or other pots containing paint brushes, on a table. They are all 2 : 3 canvases: forty by sixty centimetres, and in one case the vertical version of that.[5] Almost all of them show the far edge of the tabletop, straight or rounded. This, then, is the ground, in one colour or several, until we get to the far edge and see a background colour which we assume indicates a wall. This is usually darker than the tabletop. Thus a composition that proposes space – the

receding tabletop – is made to feel flat because the lighter table colour is pushed forward by the dark background. What happens on this little stage is what each picture is about. For instance, it matters greatly whether any of the objects break through the table/wall horizon. The blue bottle does so, and, in the same picture, a very green apple. But then this is the vertical composition, in which several objects seem to be stretching upwards, starting with paint brushes in a jar which rises into the picture from somewhere below it. In another picture, another glass jar with brushes rises similarly into the composition, and to the right of it there is a disruption, an undisclosed object or

table edge, making a dark corner, which greatly reduces the spatial ease of the rest and gives a horizontal arrangement an unexpected vertical thrust. The same picture is calmed by a clear opposition of yellow ground (table) against deep red background (wall), with a firm dark line between them. In another picture, the deep purplish red of the wall is separated from the mostly white surface of the table by an only partly visible and wobbly line, which makes no sort of barrier. The white area curves steadily from one side of the canvas to the other, to give the table an almost cosmic presence, with the light area suggesting our globe in endless space. On the table stands the liveliest of Stass's jars of paint brushes (almost a pot of unopened flowers), and there are four loose apples as well as four more gathered together on a napkin on a plate. Linear accents here and there dramatize what might otherwise have been vacant areas. Three lines over a patch of yellow in the bottom right corner remind me of Kandinsky's use of similar abstract motifs, but I also find myself thinking of the linear marks found in prehistoric cave paintings, sometimes said to symbolize traps.

It is tempting to go on drawing attention to what Stass does in these paintings. Attention is what they call for, while their subjects remain unspecific and, I suspect, not specifiable. Still lifes are not about apples and plates; the objects are significant participants in a scene scripted by the painter. I do not mean that he had a particular programme in mind for each performance, but rather that no performance was complete, no picture was ready to be signed, until it made some sort of particular sense to the artist. We may want still lifes, especially those presenting commonplace and familiar objects such as those we see in Stass's paintings, to speak of home and peace and contentment. Often they do. They certainly do not speak directly of war or disasters, nor deliver open protests against injustice and oppression. But they do very directly speak of harmony and

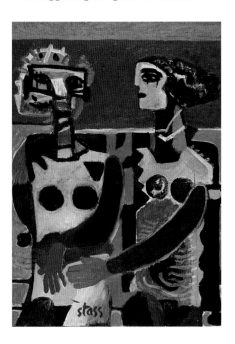

Communist Propaganda
oil on board
1968

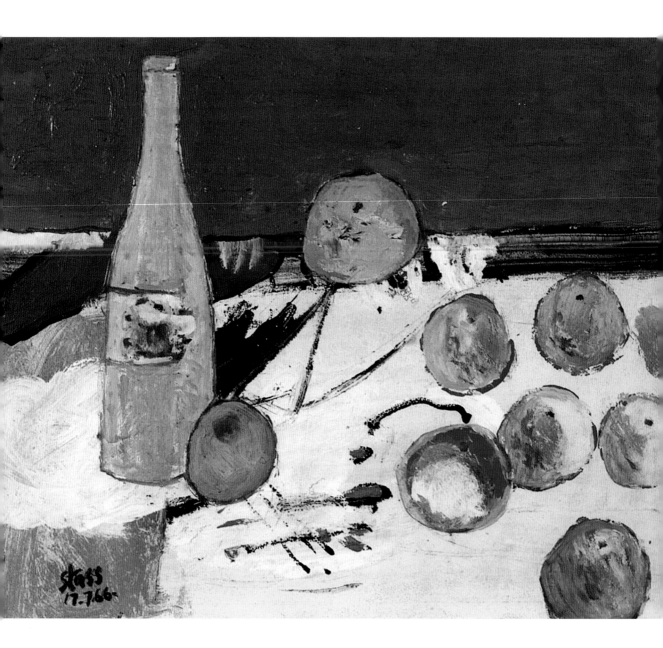

ease, or of conflict and tensions. Are they minor works, made when nothing is more pressing? I think not. Their significance is in the poetry, in the relationships of form and colour, and more essentially so than where there is another, more blatant subject. As we get to know these pictures, we learn to see different kinds of music coming from each, different rhythms, different orchestration; gentler notes and sound qualities in one, sharper sounds and degrees of agitation in another. In a sense, they are interior landscapes, and we have to be sensitive to the painter's choice of a particular scene for each picture, rugged or placid, benign or uneasy. Everything in them matters especially so much because the apparent subject-matter is so modest.

A particularly telling instance is the *Yellow Still Life* (1966, 30 x 45 cm; University of Leeds collection). This horizontal still life, 2 : 3 in proportion, has a monumental character belied by its modest size. A bottle and eight apples, plus less distinct things such as perhaps a napkin, rest on a pale yellow table. A broad, wet stroke of black marks the far edge of table, dividing it from the brown wall. The yellow and the brown are painted quite flatly; almost everything else exhibits brushtrokes and often the pallor I associate with Ensor. There is a slight sense of left to right movement, though the largest apple, in blue-green, nails the composition down by

breaking through the horizon. So does the blue-green and olive bottle to its left, but this actually leans slightly to the right and thus supports the sense of drift. (Reversed, the same arrangement would read quite differently, with the bottle becoming the controlling motif.) Like the three *The Lovers* paintings, this still life is transitional between Stass's more graphic and fully painterly styles.

The most public of Stass's paintings are those which address political matters. Stass is politically and socially aware, and responsive. He reads, he discusses, he has things that need saying. He has an urge to write, as well as a talent for expressing himself very clearly, sometimes to the discomfort of those who invite him to contribute an article. He tells me that the editors of the newspapers who ask him to write his pieces sometimes wish they hadn't. His views have always been 'left-wing', yet at times they disconcert 'liberal' and communist editors more than conservative ones. He has never been a member of any party and rejects all party lines. He is, as we used to say (why has the word faded away?), engaged, *engagé*, meaning consciously and openly concerned with the course and the often negative outcome of 'public affairs', and willing to make his views public. Why, in a democratic world, after centuries of 'progress', can ancient injustices still persist, finding modern equivalents for all

Yellow Still Life

oil on board

1966

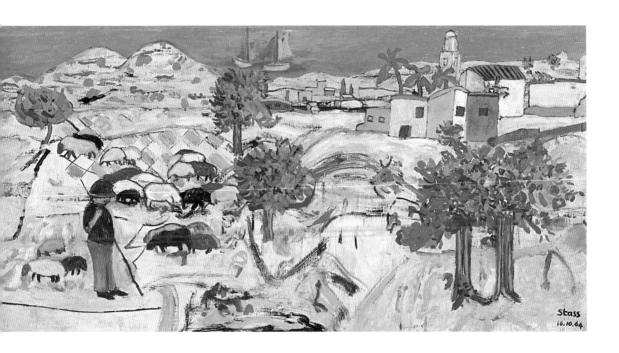

Stass
16.10.64

Shepherd

oil on board

1964

sorts of abuses – master and slave, male and female, citizen and migrant? Why have the egalitarian programmes of modern times, the promises of socialism and communism, failed so abjectly? Where is that promised land? Was the shepherd boy in a better place?

In 1964 Stass painted his double square *Shepherd*, already mentioned – a complex landscape, including a shepherd and his flock, but also glimpses of a village and of the sea beyond, in what I call his graphic manner. The greens of the trees and the blue of the sea dominate as colours; for

the rest, although each mark has its colour, we get our information more through lines than from colour forms. In the left half is a peaceful scene: the shepherd and his flock. All is well. A recent canvas, *Shepherds* (2001, 100 x 140 cm) is more problematic. In the foreground, coming towards us are two figures, one of them a shepherd with his staff. Also two other figures, closer to us so that we see only their heads, probably male and female; his face is green. To the shepherd's left are multicoloured rocks but also what I read as a large rubbish bin. There are hints of other figures on the

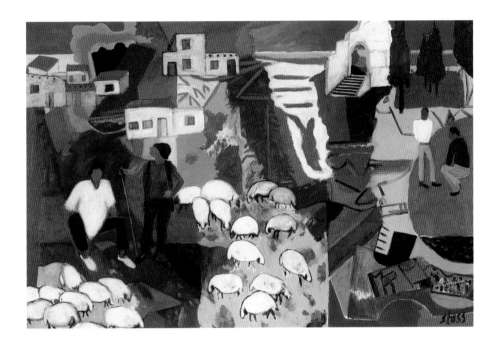

Shepherds

oil on canvas

1997

extreme left, including a weary, perhaps ageing, woman peasant walking in to the picture. The middle of the scene is filled with white sheep grazing: no disturbance there. Beyond them are the harshly jagged shapes of distant trees, a threatening barrier blocking off any glimpse of the landscape, perhaps of the sea. Everything is painted in Stass's mature solid manner, at once ancient and modern. Nothing dramatic is happening, yet there is a sense of danger, in the faces, in the little red clouds, the dark trees, the clamorous shapes on the right. A *Landscape* of 2002 (same size) seems untroubled: two men,

undramatic, on the right, with trees and hills and a glimpse the sea, and the left half of the picture filled with trees and buildings and less legible forms. I get a sense of conflict between town and country, between two ways of life. The man on the right, and closest to us, could be Stass himself, with his cap and beard, and, over his left shoulder, a staff from which hangs a basket. Is he the eternal wanderer, perhaps the prodigal son of advancing years returning home? An earlier painting, *Shepherds* (1997, 100 x 150 cm), also appears to comment on two ways of life: shepherds and sheep on

the left, and, on the right, young men talking in a setting made up mainly of abstract forms and the ruin of an old stone building. There is less sense of conflict here. The picture recognizes a contrast without asserting a preference.

A painting of 2000 (60 x 90 cm) is called *I remember* and has a markedly nostalgic quality. On the left, a vertical section is devoted to four figures facing us in the upper part, i.e. further away, and, below them and closer to us, a standing woman in white, her back to us. A similar woman stands in the larger section on the right. She is in blue, and looks towards a village of several houses. Set into this scene is a dark, angled area: a house perhaps, in which a woman sits and leans, asleep or mournful, her head resting on her arm. A vertical band of strong colours, between the two scenes contains names, below the Greek word for 'I remember'. The names are those of fellow painters Stass admires and liked, all now deceased: Adamantios Diamantis, Telemacho Kanthos, Christophos Savva, inscribed the way they signed their work. Stass, in his sixties, may well be dwelling on his past, and reflecting on where his self-evident progress in the world has taken him.

His recent work often finds him commenting on life around him. People of all sorts gather on beaches; his fellow Cypriots and swarming visitors to the island eye each other with curiosity; 'Miss World' contests and other passing entertainments of that sort; open displays of love and desire elicit the critical, envying glances of by-standers, encouraged by the unnatural attitudes with which we surround the drive to sexual union on which the human race depends – all these and other social and moral themes attract his attention, to be made into colourful, affecting and memorable emblems.

Memory of Egypt
oil on canvas
1990

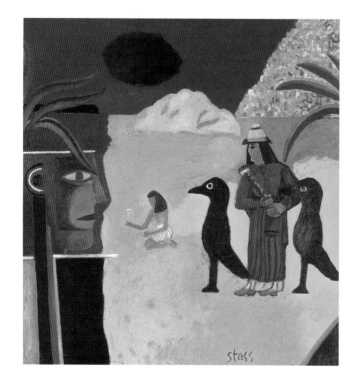

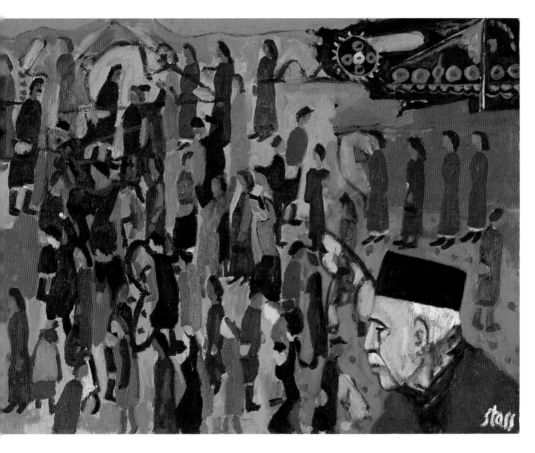

Watching

oil on canvas

1996

In 1966, the year in which his really very
innocent pictures including a naked couple
made him into a criminal, he also painted
more blatant scenes of intercourse. *The
Lovers*, in three versions, numbered one to
three, and all on square boards (40 x 40
cm), may well be a response to
censorship. Numbers 1 and 2 are
particularly direct portrayals of a man and
a woman having sex, seen, so to speak,
from between the man's feet. The bodies
are red and pink; the hair on their heads is
green. In *No.1* they lie on a mostly yellow
ground and their loving is celebrated by
flowers. In *No.2* the yellow ground is
darker and thicker, and rises to a light blue
band which appears to mark the division
between floor and a dark brown wall,

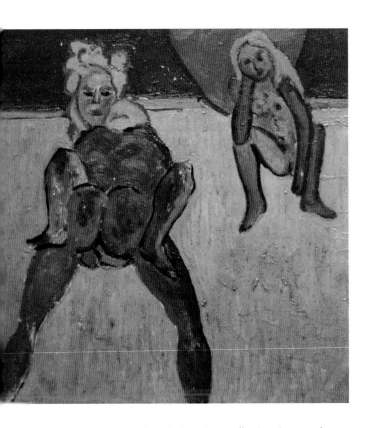

Left

The Lovers, No. 1

oil on board

1966

Right

The Lovers, No. 2

oil on board

1966

though there is no effective change of plane. Instead of flowers, the lovers are here flanked by another figure, a nude but relatively colourless woman that recalls Gauguin. Perhaps she is unhappy at being excluded; perhaps she is enjoying what she sees. Our reading will depend on our own experiences and values. A third *The Lovers* shows two generalized animals, sheep perhaps, mating in a domestic interior. This curious fact, once we notice it, makes one wonder whether Stass is here being metaphorical. Another painting of the same size is called *The Kiss* and represents precisely that: male and female heads meet at their lips. Eyes gaze at each other; the sense of union is powerful. There is not much else, and in this way the picture recalls Brancusi's famous early rendering of *The Kiss*, in a profoundly expressive but 'primitive' form that implies

fierce criticism of Rodin's well-known embracing nudes, also known as *The Kiss*. In Stass's painting everything else is summary: the pinkish reds of the faces, the blue-green hair, the ochre of part of the background, picking up from his neck and shoulder; her red neck curtailed to leave an area of cool white, with Stass's signature and an X for a kiss, picking up on the middle area of the background. The woman seems to be the more important presence in the composition, and in fact is given more space than the man. But this is primarily a function of the left-right reading that guides most of us instinctively: our

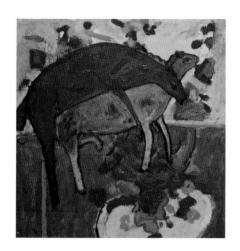

eyes enter past his head to hers and linger there. Seen in a mirror, this emphasis is reversed though the woman's head still occupies more of the picture.

The Arts Council collection includes a rich and colourful square painting of *Bathing* (c.1968, 61 x 61 cm), an idealized image of naked women sunbathing and splashing about in shallow water. It is an addition to the long tradition of Bathers developed in western art during the nineteenth century, and stemming from an older tradition of mythological subjects involving nudes and water. It is also a milestone in Stass's development of a relatively graphic painting manner into one in which colour and brushwork produce a painterly harmony peculiar to himself. No message is offered by it but that of the love of women, of nature and of life. We

shall find that this super-real theme of physical and mental joy reappears in Stass's work, balancing other works in which he questions human behaviour and the values it represents. Often his theme is that of sexual jealousy, as in *Disapproval* (1994, 76 x 100 cm), in which we see a young man bringing flowers to a girl who lies on a bed, almost naked, while a row of women in the background, resembling a file of mourners, express their disgust by their gestures and black dresses. Or in *Whisperings* (1995, 75 x 100 cm) in which men and women are seen gossiping slyly about an embracing couple. A mysterious form in the right-hand top area suggests both a heart and a clock: life is short.

The Lovers, No. 3
oil on board
1966

The Kiss
oil on board
1966

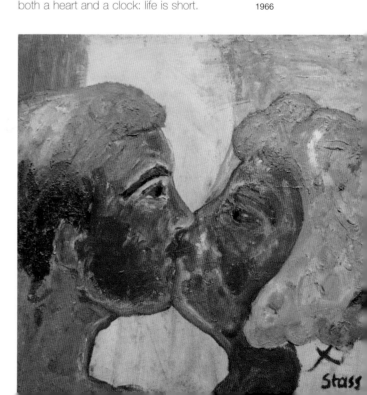

**Refugees Waiting
to go Home**
oil on canvas
2000

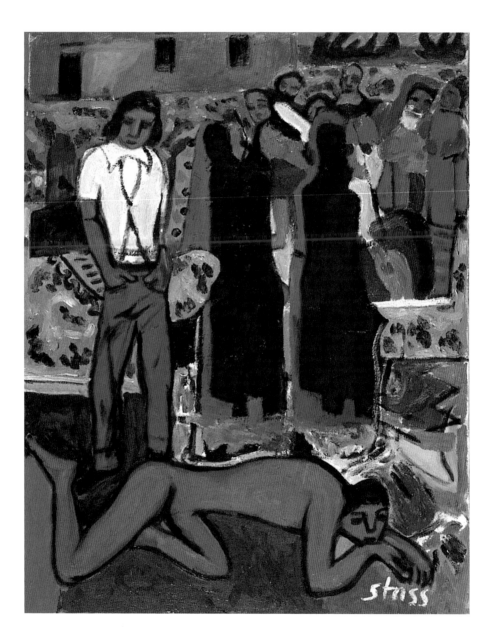

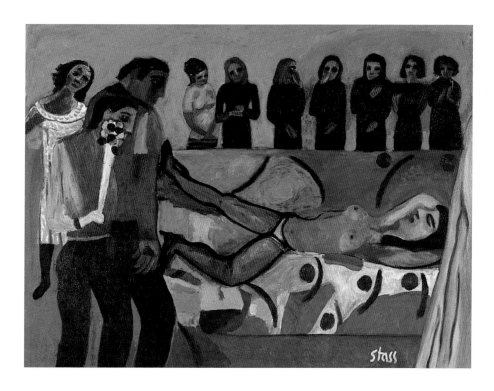

Disapproval

oil on canvas

1994

Human rights – Man's inhumanity to woman (1999, 100 x 76 cm) is an almost biblical scene in which a woman, lying on the ground, is being stoned and shouted at by a vast crowd. She has sinned in their eyes, like the Woman taken in Adultery in the Gospel of St John, whom Christ forgave. We all know that we are not fit to cast the first stone. The god of wine, Bacchus or Dionysus, is the hero in Stass's painting *Dionysus and Ariadne* (1999, 100 x 140 cm), a modern image exploring an ancient theme and thus making a link several major modern writers have used in their poems, plays and novels. Dionysus is the chief and most visible figure in it, a twentieth-century Dionysus, a bottle in one hand, the other raised and holding a glass filled in celebration. Ariadne stands to his right, golden-haired and prettily dressed, still grieving over her abandonment by Theseus. An embracing couple and, at the top, a pair of lovers so intent on their union that they have become one body, may be part of Dionysus's and Ariadne's

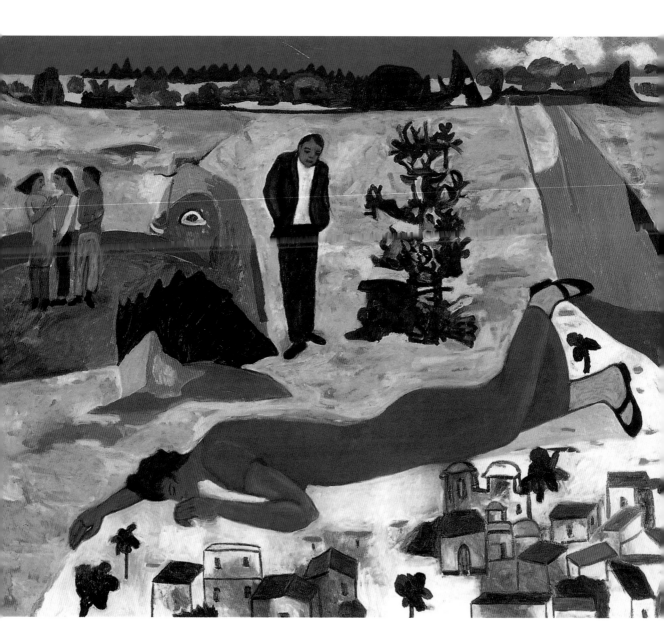

imaginings, but to the left of the picture is a crowd of dark figures who will surely sit in judgment while, on the right, there enters a bearded man (the painter himself) bearing a basket of flowers.

In devoting much of his work to celebrating joy, love and sexual union, Stass joins a surprisingly small contingent of modern artists that includes some of the very best, among them Matisse, Brancusi and Chagall, expressing the joy of sex quite unambiguously, Bonnard, obsessed by the theme and, one presumes, shy of grasping the reality, and Picasso, who made many images of desire and bliss but also many others in which sex is lampooned as a monstrous hunger. Behind Stass's sometimes sardonic observations one senses an underlying affection for the human race, even in its foolishness. And when he is being critical, the artist's instinct is usually to develop his image towards harmony or, at least, pictorial vigour. Without that art cannot live, just as we cannot live without sex.

On some occasions he is roused to pictorial anger, and this relates to politics: to the pressure of political dogmatism and to the misery and sometimes death caused by political extremism. With his deep love of Cyprus, he was always alert to the inner and outer pressures upon the island. In 1971 he painted his prophetic *Liberty abandons Cyprus* (140 x 153 cm).

This is a powerful allegory, the boat, with its resplendent sail and with birds swooping over it, coming away from the cliffs of Cyprus under a pink sky. A large picture, it has the character of a mural, and reminds me of historical scenes and allegories painted by Scandinavians a hundred years ago, when nationalism was a pressing issue there, and of the illustrations to Slav myths produced by great artists such as Bilibin in Russia around that time. The ship sailing towards us suggests the departure of Odysseus from Troy. In 1973 Stass painted a second *Liberty abandons Cyprus*, a large, almost square picture. This is not an allegory but conveys a sense of dread and shock by representing a silent crowd of modern, anonymous people, standing outside a church under a heavy, thunderous sky in which just one angelic spirit of Liberty hovers. Another painting with this theme, done in 1970-71, is *Trojan Horse* (92 x 152 cm). This is an impressive combination of a semi-realistic scene of modern Cyprus, with buildings, people, animals and beyond them a landscape, with references to Homer's *Iliad* and other poetic elements – the angel, the large naked man in the foreground, observing, one feels, not part of the scene.

Stass has stressed that, coming back to Cyprus from England for summer visits, he could not help seeing the situation in his home country in sharply objective terms. Every day, the newspapers carried

The Dream of the Red Girl
oil on canvas
1997

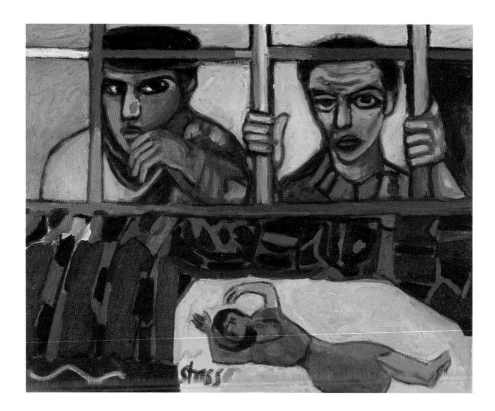

Waiting
oil on canvas
1989

stories of violence including murders, and of government buildings being blown up in the conflict between General Grivas and Archbishop Makarios. He could not but comment on all this and on his thoughts on what the consequences would be. *Trojan Horse* foresees betrayal, and indeed this followed a few years later. We see his response to what was happening expressed very clearly in *Folk Motif*. This modest-sized picture of 1991 uses a traditional formula inherited from religious art, of a central head or figure surrounded by others. Here the hero is Colonel Grivas, shown head and shoulders, attended by four much younger, positively boyish, followers. Stass was horrified by the fascist values promoted by Grivas, and the way he associated them with a pretended adherence to Christian priorities. Blue

and white flags identify their politics; a swarm of little crosses, suggesting graves and their methods. Their images hover above a simple image of a Cypriot village. We almost miss the point that Stass here uses a formula of celebration to express abhorrence. His art teaches us that portraits have many uses, including that of asking about 'disappeared' individuals, the countless victims of politics.

After 1974, Stass painted the large canvas *Partition* (1980, 179 x 90 cm, State Gallery of Contemporary Cypriot Art collection, Nicosia). In effect a double square, the composition relies on a pale ground to unify pictorial episodes that suggest the conflict that led to the partition of the island and the way it divided towns by means of makeshift

barriers, forcing families to leave their natural homes and become exiles in their own land. The figures, buildings and other motifs speak of these events. In not very specific terms – mostly for its unhistrionic display of victims and the painter's deep sympathy – I find myself reminded of certain of Chagall's epic paintings, such as his *The Revolution* (1937; only a small version survives, a horizontal double square canvas), or his *White Crucifixion* (1938). Both paintings were occasioned by political events and threats: civil war in Spain and the bombing of Guernica, and Nazi pogroms against Jews in Germany, with thousands sent to concentration camps while synagogues were being burnt to the ground. Both painters succeed in conveying their horror at what they are forced to witness, and their feeling of pity for suffering humanity, while also quietly raising the question how it is that a nationalistic urge to power and the

Red Nude

oil on canvas

1984

institutionalized religions can support such violations.

Several of Stass's most recent paintings comment on the plight of asylum seekers, their rejection by society as though they were not part of the human race, their existence in a sort of limbo while they wait for repatriation, their poverty and loss of purpose. Two rather different paintings of 2000, both titled *Illegal Immigrants*, show such individuals, indoors and outdoors, with one of them holding a begging bowl. The blankness of their faces conveys the basic message. Among other paintings of 2000, *Refugees* shows a cluster of victims, old and young, amid barbed wire in landscape, and, *Refugees waiting to go home*, a vertical composition, has a group of people fairly close to the front of the picture, and, below them, a young man, naked and lying on the ground. These images are full of questions, and viewers are left disturbed by their inability to resolve them. In 2001 Stass painted two versions of *Mothers of missing persons*. The first is packed with faces, the faces of the searching mothers and the faces in the pictures they are carrying – in a culture in which icons are windows onto heaven. On the left, a woman stands, still asking but without hope. The other includes a crowd of miserable people, with, in the left half, a multiple figure whose disrupted face expresses

the misery of this ordinary, world-wide situation. These are among Stass's most strident inventions, yet their force does not depend on great dramatic gestures but comes from the pressure of faces and bodies in compositions that are dislocated in themselves.

Sometimes Stass makes his point by highlighting the death of a named or unnamed individual. Three such paintings date from 1996. *Dead hero* (75 x 100 cm) brings the deceased close to us, lying under his patterned bedspread, with mourning women either side of him. *The Murder of journalist Kutlu Adali* (100 x 100 cm) is a square painting subtly divided into zones or scenes that present a great number of people as well as the dead man, top left, and buildings in a summary landscape. This is an iconic painting, outside the classical tradition of treating each picture as representing one more or less coherent scene. It has a markedly religious character because of this episodic arrangement as well as the general flatness. The allegorical painting *Freedom and death* (75 x 100 cm) also has something of the icon about it, in the concentration and centrality of its figures, but Stass has emphasized the classical stage character of the scene by giving some of the figures pronounced shadows, asserting space and recession. Facial expression is made to carry much of the meaning of these images. In some of his

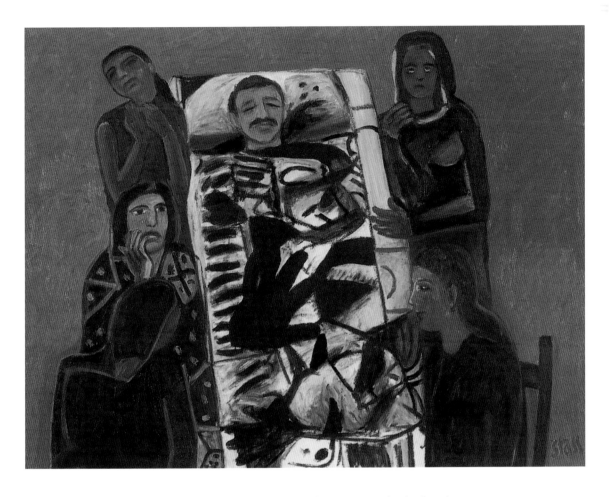

latest paintings, Stass has used faces as the main elements of paintings referring to terrible events, as in two versions of *Terror in Jerusalem* in which symbols of death and threatening hands coexist in spaceless compositions as though they were the typical symbolic public still lifes for our times. His concern for all attacks upon human rights led Stass in 2000 to paint *Freedom of Expression*, a vertical canvas (60 x 90 cm) in which a nightmarish oppressor, ancient and modern, backed by barbed wire, a wall and a pool of blood, triumphs over human beings and newspapers that had spoken up for freedom. A swastika is inscribed over this monster's face.

Freedom is Stass's essential demand. Curtailment of freedom, by politics or by conventional social illiberality, is anathema to him, rousing this normally benign and affectionate man to anger that requires expression. Monstrous imagery in his art has the effect of a crashing discord amid harmonious and usually simple sounds. This was so already in 1969 when he painted

Dead Hero
oil on canvas
1996

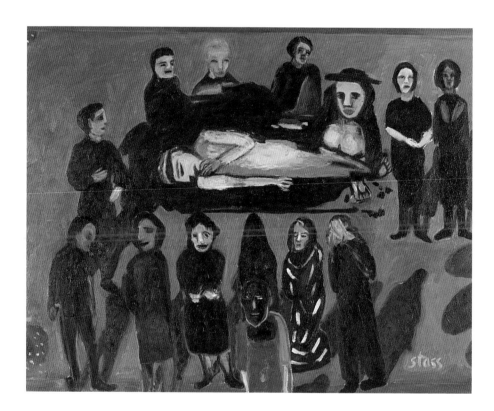

Communist propaganda (83 x 60 cm).
This was, in fact, a response not to
propaganda for or against Communism,
but to being accused by the Greek
police, of being a Communist himself.
He was in Athens, on the way to Cyprus
with a group of students. A policeman
examined one of the students' drawings
and announced, 'This is not modern art;
it is communist propaganda'. The result,
back in Canterbury, was this painting of
two much abstracted women. They are

seated; the one on the right reaches out
to the other, while she on the left seems
to pull away slightly. The head of the first
woman is in profile; she looks at her
partner. The other woman's head is full-
face, but it is a monstrous face, closer
to a Picasso sculpture than to any
painted face in art history. Stylistically,
the image as a whole stands out from
Stass's work, being self-consciously
stylized in a post-Cubist way. In his
more recent protest paintings, he brings

skulls and grotesque masks into his own, characteristic, artistic language, and again one thinks of James Ensor and his awesome parade of death and of humanity at its ugliest.

What does Stass wish for and dream of? *Pagan Spring* (1968, 143 x 210 cm) is perhaps his most optimistic statement and one of his largest paintings. The proportions of the whole are 2 : 3. The twenty rectangular scenes into which the painting is divided are delineated free-hand, and are not neatly geometrical, giving what could have been a mechanical grid a certain flow and dynamism. All but one of these small areas present cheerful, friendly images, with love and desire prominent in some of them but also other events or emblems, including a hill with little trees, topped by a glowing apparition; a winged horse and a herm; two horses, birds flying, flowers, and so on. His theme is clearly youth and the energies and dreams of youth (spring), free of unnatural restrictions (the pagan world). The remaining area is left green, which suggests nature but may also symbolize hope. He seems to be leaving a space for a modern metaphorical scene equivalent to the others. The picture's format derives from medieval, and especially Orthodox, Christian art, so that the work is experienced as a prayer against everything that in modern times deprives us of joy. In front of the grid of little scenes we see

Ganymede, the young shepherd, transported to paradise by Zeus in the form of the eagle, as related by Ovid. In medieval times, Ganymede was sometimes explained as the antetype of John the Evangelist, and the eagle was seen as an image of Christ.

I have emphasized that Stass has always been a great reader. Here it is worth adding that he has studied classical mythology, and is the author of a book on the subject that first appeared in 1981 and has been re-issued twice.[6] He is also a published poet. To put something complex and valuable in the simplest terms: Stass's heritage of the imagination, of the mythologies of ancient and more modern times, is always with him, even when his attention focuses on contemporary issues. He reads the present in terms, also, of the past. This gives his commentary a wide and timeless relevance. He would say, perhaps, that this must be so for anyone with deep roots in Cyprus and the Mediterranean. It seems to me that this awareness gives even his protest paintings, when he is saying 'No!' to what is happening, an element or context of warmth. For example, his modestly sized painting with a long title: *School teacher of Carpasia and enclave pupils* (2000, 60 x 90 cm). We see the woman's head and shoulders, strong and confident, and then notice the grey, fearful faces of the pupils, and bits of barbed wire around and in front

School Teacher of Carpasia and Enclave Pupils

oil on canvas

2000

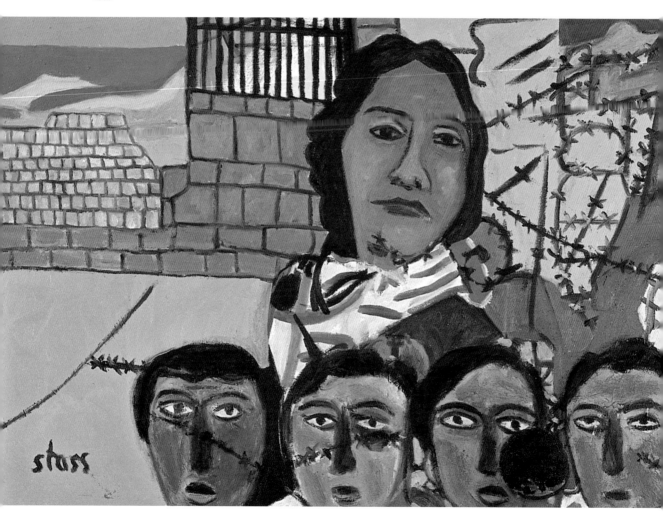

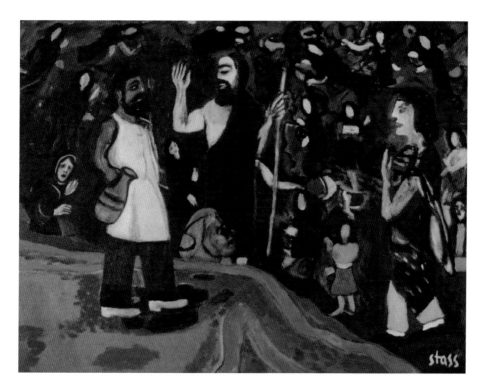

**Ulysses in the
Underworld**
oil on canvas
1995

of them all. The picture is praise as well as protest: 'It refers to a very brave woman teacher who defied the Turkish army in the occupied district of Carpasia, and continued to teach the children of her village as if she was living in normal circumstances. She suffered indignities and intimidation for many years, until she was forced to leave.'[7]

Stass's natural inclination is to observe the world around him and to dream about it optimistically. For all its many faults, it contains so many good things, from sunshine, land- and seascape to handsome places, and people (including beautiful individuals) some of whom are friends, and love and benign social encounters, as well as working scenes, in the studio, in the art college, all of which define us in this world. Many a modern artist is unable or unwilling to say this, but Stass does not fear pleasure, and much of his art is positive. But without added sweetening. He has always painted nudes, and in recent years he has painted

several pictures of *Visitors* (1997), *Neighbours* (1999), *Artists* (2002), etc., all of them convivial scenes. His *Wedding Scene* (1993, 37 x 28 cm) is a friendly freehand snapshot of the newly-weds and one pair of parents. *Wedding* (1987, 80 x 80 cm) is a busy scene of lots of wedding guests out of doors among houses: conviviality again. He painted it for the marriage of his daughter Margaret to Costas Coutsoftides, an architect. Actual and inner sunshine pervades these pictures.

There are several pictures of models, dressed and undressed, and two entertaining pictures of Stass in the studio. In one of these, *Portrait of the Artist* (2002, 40 x 60 cm), he appears as a picture within the picture, propped up on an easel; to its right is the upper half of a good-looking girl, dressed; to its left is most of a naked model, seen mainly from the back, and it seems to me that the hand in the inner picture is reaching out towards her with some eagerness. In another studio scene, *Artists at Lempa*

The Visitors
oil on canvas
1997

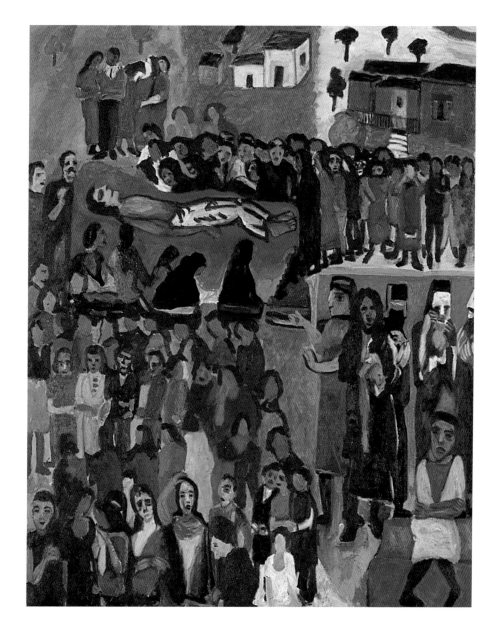

The Murder of Journalist Adali
oil on canvas
1996

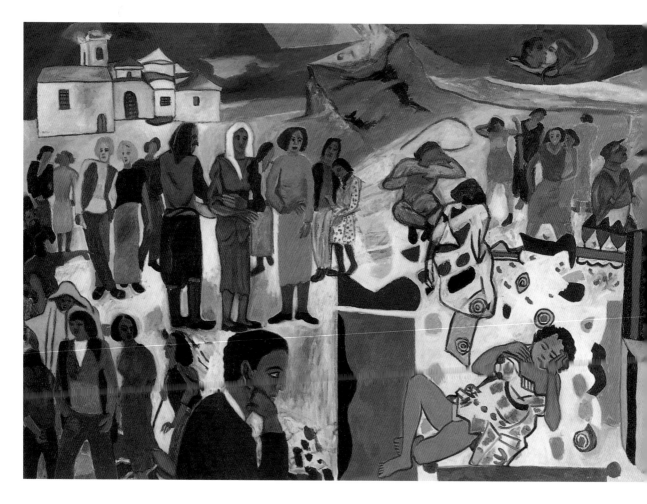

Dream of March

oil on canvas

1997

(2002, 40 x 60 cm), we have Stass standing in front of a painting, perhaps studying it. Other figures are there, students probably, one of them on the floor, touching a picture. But in the bottom right-hand corner we see a nude girl holding a picture that shows a death's head wearing a cap (Stass's cap?). She says that life is good but short. Again and again, in all these Stasses, there is a yellow ground conveying good spirits. His forms are strong and more or less unmodulated within their outlines. We could call this manner simplified realism, in that it tells us unambiguously what everything is but does not go into detail

about it, neither for additional information nor for ornament. A larger picture, *The Dream of the red girl* (1997, 100 x 150cm), is dominated by the long figure of the sleeping girl close to the foreground, though clusters of little buildings come between us and her, as well as a man standing close to the centre of the composition who gazes at her intently. All this is situated in a landscape that gradually reveals all sorts of unrealities in it, apart from the miniature scale of those buildings. Some of these things look a little threatening, such as the jagged, gesticulating object to his right, a sort of thistly plant perhaps. But the general effect

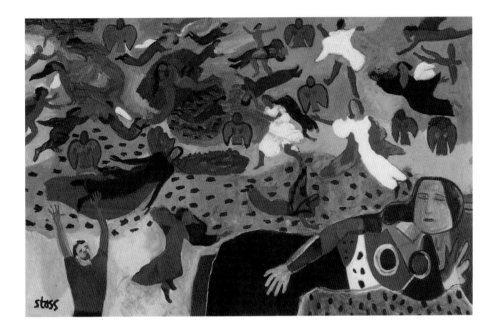

Life in the Heavens

oil on canvas

1997

is dreamy, and the yellow land and blue sky reassure us as to the character of that dream. Another large dream picture is *Dream of March* (same year, same size) in which we see, first and closest to us, a young man looking fixedly at a sleeping girl, dressed but lying with her legs uncovered. There are many other figures, couples and others, and a pair of kissing heads in the sky next to a new moon. This is evidently not realism, and there are other passages in the picture which cannot be explained in realistic terms. So here too we have a realistic mode accommodating surrealistic imagery to move the scene onto another plane of experience.

We all live in our imaginations at least as much as in the 'real' world, so that it is odd to find so many supposed 'art lovers' hoping for what they call realism. Moreover, even the most realistic painting is a slice of unreality in that what we see, what we notice, is not the material reality of paints on board or canvas but an illusory object or scene. Art is, of its nature, both reality and unreality. Stass gives this duality full reign in yet another fantasy: *Life in the heavens* (1997, 100 x 150 cm). This imaginary scene includes dressed and naked figures, singles as well as pairs, accompanied by angels and cherubs, floating above a much larger

reclining woman. She may be asleep; she reclines bottom right, at once earthy and handsome. There is something of Picasso about her strong but distorted form. Much smaller, and to the left, we see the upper half of a young woman, both arms raised, who seems to be trying to catch her attention. Nothing is spelled out. The sky could also be land and sea. There is a general expectation of happiness.

When Stass turns to religious and mythological subjects he is not moving very far from his own reality. These old themes and their burden of meaning are part of his mental life and his environment.

One of his earliest paintings, perhaps the very first, is *Pain of Mother*, painted in 1957 on a wood panel (62 x 42 cm). He has recently retouched it, confirming and emphasizing the outlines and thus asserting its character as a sort of icon of the Madonna and Child. A subsequent picture of *Love* (1979, 50 x 65 cm) shows a mother and child, or Madonna and Child, thinly and delicately set into a context of arabesques that resemble wrought-iron work. The icon character of the image is inescapable, and is confirmed by another painting of the same year, *Hesitation and Agony* (70 x 100 cm). Here a figure of Christ crucified is shown,

Death of Lazarus
oil on board
1976

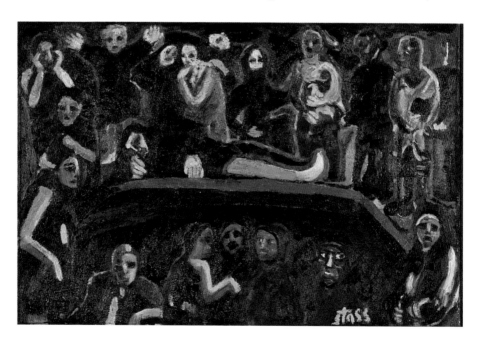

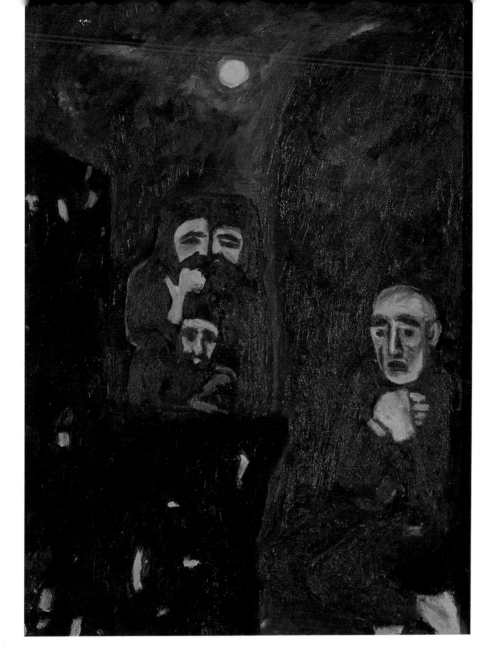

**St Neophyte,
the Recluse**
oil on canvas
1996

without the cross, against a similar background of linear arabesques, but arrows point to his pierced hands and feet and, between us and that image is the upper half of an observing figure, a dark silhouette contrasting with the clearly legible and expressive Christ. The title takes us further: Stass is referring to the invasion of Cyprus in 1974 and the island's agony while Greece turns its back. Sometimes he paints biblical subjects. One series, which he has continued over some years, appears to have been stimulated by his setting such subjects as a project for his Canterbury students. In 1976 he painted a *Death of Lazarus* (56 x 76 cm). This is in fact a subject rare to art history; it is the Raising of Lazarus that has

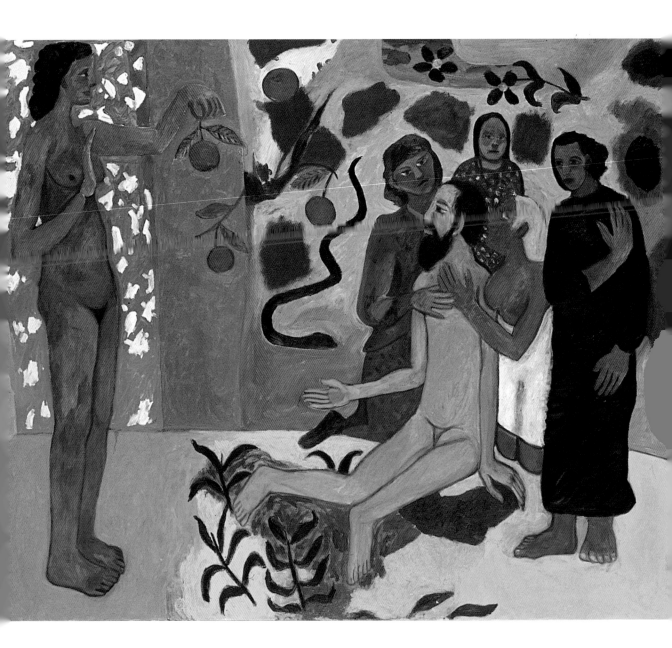

often been portrayed as a dramatic instance of Christ's power. Stass has created a dramatic scene of the reclining dead man surrounded by mourners, all painted rather broadly, light forms against dark. *A Deposition* (1987, 56 x 76 cm), also very much light against dark, shows the pale body of Christ carried by mourners among other figures expressing dismay. In 1996 he used much the same opposition of tones for a vertical canvas (86 x 66 cm) of *St Neophytos*, the recluse who dwelt in the hills above Paphos in the twelfth century.

Odysseus in the Underworld (1995, 75 x 100 cm) could almost represent Christ's Descent into Limbo. In fact, this subject, dear to the Church in medieval times, is an echo of similar events in pagan mythology, with Odysseus, Orpheus or Hercules as their heroes. In Stass's painting we see many summary figures, but also two larger and more prominent ones who may be Stass himself and his wife, Mary. Odysseus himself resembles in stance and character another Stass Odysseus, painted the same year, in *Odysseus and Calypso* (96 x 76 cm). As Homer relates, the nymph Calypso sheltered Odysseus after his shipwreck. He lived with her for eight years, and she promised him immortality if only he would marry her and stay, but he would not, always mindful of his own home and of Penelope, his wife. We see him, naked

and posed rather impressively, addressing a half-naked Calypso, soft and sad at his rejection. The male figure recalls Ingres, the classical form contrasting very effectively with the woman, and giving the painting its pagan note. Without that, the scene could have been a modern male/female confrontation.

A *Temptation of St Anthony*, painted in 1997 (100 x 150 cm), strikes a note more akin to Stass's other large paintings of that year than to the earlier, dark religious paintings. Perhaps the subject itself has something ambiguous about it for the modern, agnostic mind. There is the saint, an ascetic figure, barely male, seated rather awkwardly and supported by companions – one of whom sports a proud bosom. To the left stands a tall nude, almost the full height of the canvas; she is tempting the saint with an apple as well as with her beauty, while the serpent slithers near-by. But the colours are bright, the scene more cheering than troubling. The floor of the interior of the saint's cell is yellow; plants and other apples add decorative accents, as do abstract blobs of colour. The bosomy woman, with her yellow hair and white skirt, seems more a friend than a dangerous seducer. It is the saint himself who sounds a negative note. He does not look likely to surrender, but then one wonders whether he has it in him to feel desire.

Temptation of St Anthony
oil on canvas
1997

Detail of Great
Wall of Lempa
2001

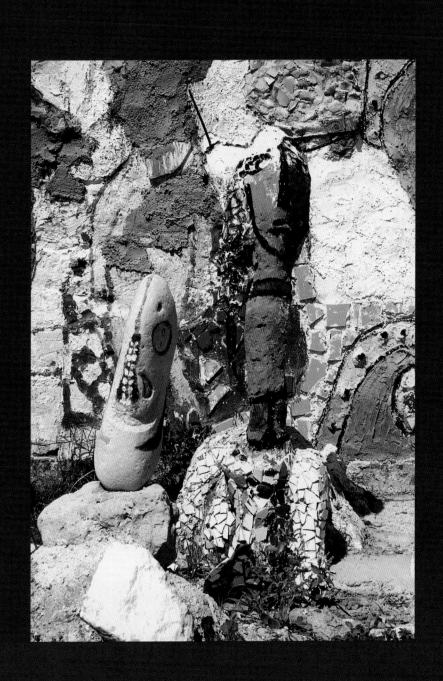

Peace
painted wood
sculpture
1995

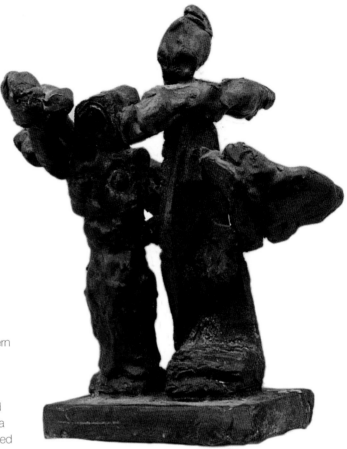

M any modern painters have made sculpture; some modern sculptors have also painted. Sometimes, with Picasso as also with Michelangelo, we wonder with which specialism we should associate artists. Gauguin, so important a painter, made a number of powerful carved and modelled sculptures. When Stass studied in Leeds, the old art-school divisions between the painting, sculpture and other departments were being demolished and students were being made to work in a range of media and techniques, traditional and new. It may be fair to say that for Stass painting is his primary business while sculpture is an additional practice, which he pursues at intervals with vigour and, it seems, a sense of fun. Since 1980 he has made a number of constructed wood sculptures, largely of found elements, to which he adds colour and patterns. *Tree* (1980, 142 x 56 x 8cm) is a bright assembly that seems to start at

the bottom like clustered towers to become one rising plank, which is then topped by diverse forms, including leaf shapes. Yellow and white, as well as red paint, make this a cheerful object that does not pretend to imitate any tree in nature. Stass made a *Poetry Tree* (early 1990s, 425 x 92 x 92cm) which stands in the foyer of the National Theatre in Nicosia.

Peace (1995, 120 x 50 x 45 cm) is a complex, highly poetic work. At the foot, we see a woman's head, presented quite naturalistically, and also a hand that may

Two Figures
cast bronze
1984

Tree
painted wood
sculpture
1980

be raised against her, perhaps to silence her. From her head rises, as though balanced on it, a weighty piece of wood, presumably a discarded furniture fragment, from which sprout a variety of other elements, soft forms and hard, wholly abstract forms as well as others that suggest limbs or tools. At the top is a dark shape that may be another head; there certainly is another hand, similar to the one below. Bright as well as dark areas and elements bring visual variety, and a pattern of coloured spots. Also at the top is a board, almost a picture, on which we see the outline of the dove of peace, complete with its olive branch. Other forms, toothed like a saw or a monkey wrench, suggest conflict. Stass evidently has it in him to create a major public sculpture on a theme of this sort, but when he was selected to make a large sculpture for Nicosia, continual interference by the commissioners made him abandon what could have been, for him and for the public, a major undertaking and a lively and significant work. *Peace* is in fact a preliminary study for a larger sculpture Stass proposed for the entrance to a new Court House in Paphos. It was rejected.

Two wood constructions of 2001, about 60 cm high, share the title *Fishermen*. They are indeed figurative without attempting any degree of naturalism; strong forms, supported by painting which is done partly to decorate the figures and

partly to identify them. One of the men is in profile, and holds a fish as though to show it to his colleague. The other is frontal, and less easily read as a figure although his left arm is clearly shown. Stass has at times worked in metal, modelling forms and then casting them in bronze. But he has also enjoyed welding metal, a technique that allows a great freedom in configuring diverse elements. In 2002 he made a number of such metal constructions. They are mostly black or unpainted, with the colours of the metal speaking up for themselves, though one of them is painted a matt yellow all over. Each has its own character. All are vertical compositions. Some of them hint at figures, especially when they stand on two points. Others remain quite abstract though their total forms, or the elements of which they are constructed, may bring associations with them. One of them, entitled *Gate* (117 x 94 x 50 cm), does in its arched form suggest an entrance, but there are other, more solid forms at its foot, and the lines of the gate are invaded by other linear forms, a writing in space that holds one's attention as though it were a simple code. All the Stass sculptures I have seen are interesting in themselves, and at times fascinating as well as cheering. They should be better known.

How can we relate these sculptures to Stass's work as painter? Visually the sculptures seem quite different, and the

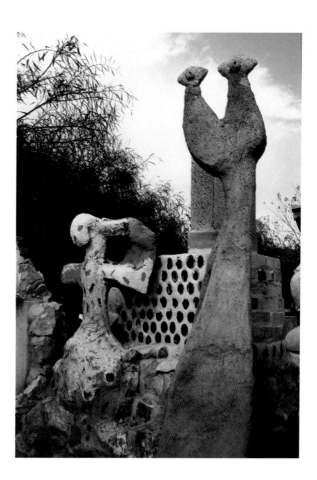

methods involved – sawing, assembling, and painting in the case of the wood constructions; cutting, assembling and sometimes adding colour to make the welded metal constructions – have to be different in character from those he uses in painting pictures. Materials and methods to a large extent determine any

**Part of the Great
Wall Of Lempa**

artist's relationship to his work as it proceeds. But the artist remains the same person, and the process is not wholly different. Most important, we must not underestimate the extent to which Stass's paintings are assembled. I don't mean in the physical sense (though, as in *Homage to Ben Nicholson*, he has sometimes used collage as a physical method close to assemblage). I mean that he invents his subjects, decides how to stage his scenes and bring out their meanings, by a process of mental assembling. The idea from which he starts each painting, even, or especially, if it is one he has pictured before, is realized on the canvas as he works. One form suggests another; a pattern requires an answer from another pattern; a symbolic addition can focus the sense of the image as well as complete its visual presentation. All this applies to the sculptures too. When Stass makes figures, as in the *Fishermen*, he comes close to his own scenes of life around him. I could imagine him making a splendid *Dionysus* as a wood construction, not wholly unlike his painted Dionysus of 1999. When Stass makes more or less abstract sculptures in welded metal he may seem to be closer to making drawings, but in fact many of his paintings include prominent linear elements and other forms that, taken out of context, are abstract. Stass's mature style as painter, fusing post-Gauguin means of expressive representation (which he proudly calls 'old-fashioned') with potent elements drawn from Mediterranean traditions of religious art and from a wide range of folk art – a complex of attachments which Gauguin would have approved of – appears distinct from his style as sculptor, which owes something to the Surrealist idea of the mysterious, assembled object and to the wave of welded sculpture that developed internationally in the 1950s and '60s. The use of found pieces of wood or metal is not wholly different from Stass's imaginative dipping into his mental reservoir of things seen in life and in art. Just as the found forms used in his sculptures stimulate him to give them meaning in themselves or by addition to other forms, the shapes and images he brings to his paintings play a fruitful role in enriching them. In both cases, they are active, collaborative elements; they do not merely supply a predetermined want. Stass continuously improvises, but out of vast experience and knowledge.

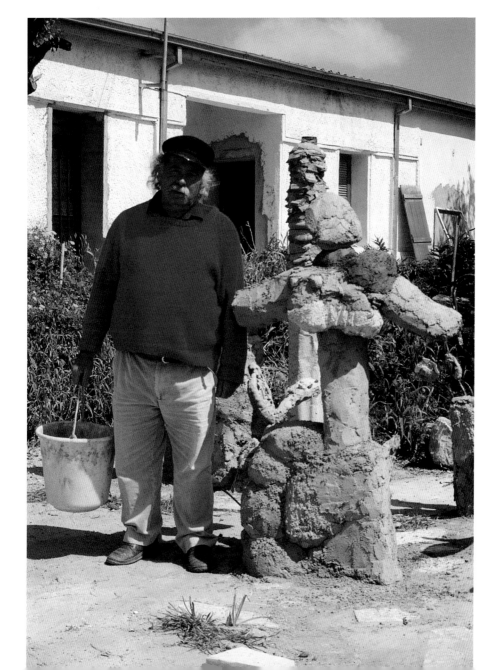

Stass at the start
of the Great Wall
of Lempa
1992

Entrance to the
Cyprus College
of Art
2001

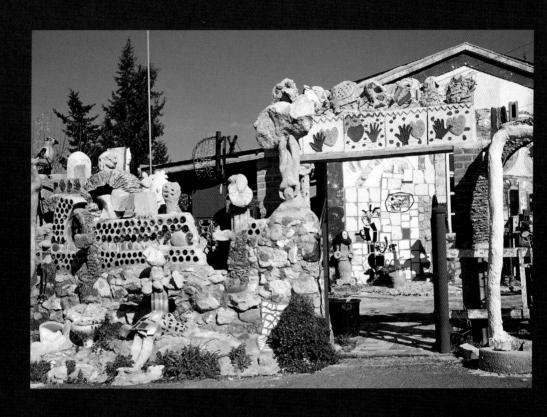

Stass's practice as painter and sculptor, as teacher and occasional collaborator, is manifested in what his son, the art historian Michael Paraskos has baptised 'The Great Wall of Lempa'.

In 1981, when Stass moved his College from Paphos – which was rapidly becoming a very busy tourist centre – to Lempa, a few miles to the north, into a village that was largely deserted, archaeologists from Edinburgh were at work there on what they judged one of Cyprus's most ancient residential sites. For the rest, the place seemed moribund. The Ministry of Education and Paphos Municipality helped Stass renovate some cottages as accommodation for students and to take over a disused school as the College's core. With his assistants and students, Stass has added light studio structures since then. All the buildings, old and new, stand informally in a piece of ground otherwise occupied by orange and fig trees and other growths. Nature, together with nature's light and dark and weather, shares the territory with the College's simple enclosures. And around all of it runs the the sculpture wall, itself a growing, changing thing.

Stass has said that he hopes to finish it before long. One wonders whether that can ever be. Or perhaps he will have to start another one, or perhaps a collaborative monument in some central position in Lempa (which meanwhile lacks a centre). I cannot imagine his impulse ever being satisfied. As it is, the wall is famous, attracting not only tourists with their cameras but also the media of several countries. Most recently, BBC Television featured it in a programme about the island and Lempa is returning to life because of the College and its wall. This just could turn Stass into the Gaudí of Cyprus – a connection neither of them

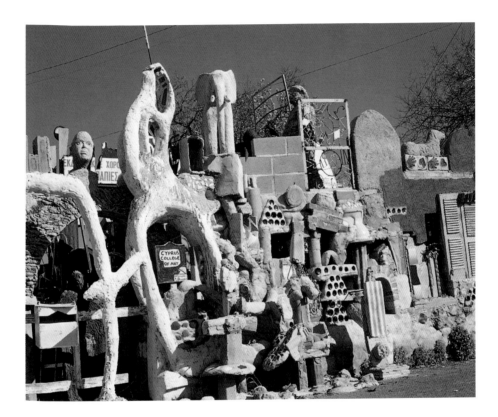

would entirely welcome since the
deceased Catalan architect, whatever we
think of his buildings and his decorative
and grotesque grottoes and seats, was a
convinced fascist.

Before all else, the wall is a major exercise
in recycling. Students and visiting
instructors make sculptures and other
objects, and often leave them behind
when they go. Daily life adds its own

detritus. Friends and acquaintances,
possibly in refurbishing or rebuilding
Lempa, give Stass pieces of this and that
– window frames, louvred shutters, old
roofing tiles, unused air bricks and
concrete slabs, and so on. All such things
are likely to be incorporated in the wall. A
concrete mixer is at hand to provide a
basic material, partly to glue things
together, partly for new forms to be cast.
Together with rows of empty wine bottles

Stass and students
at the Cyprus
College of Art

NOTES

[1] The art historian and critic Michael Paraskos touches on the situation of contemporary Cypriot art in his short article on the State Gallery of Contemporary Cypriot Art in the Cyprus Airways in-flight magazine *SunJet*, vol.11, no.6, Spring 2002, pp.62-5.

[2] When I asked Stass about his frequent use of yellow, he invited me to look out of his window and observe the yellowness of the landscape. He lives in a world of yellows.

[3] James Ensor in 1888 painted his masterpiece, *The Entry of Christ into Brussels* in 1889 (now in the J. Paul Getty Museum at Malibu, California). In its strident way this represents the future event of the title as a carnival procession which is also a political march: a compaction of horrible or at least caricatured faces including a death's head, almost all of them coming towards us. Rich in colour, and marked by heavy, intentionally clumsy brushwork, this enormous painting has a vehemence rarely found even in modern art. Stass's painting, which may incorporate some memories of this Ensor, is relatively calm in manner, and this way more universal: an image of protest that does not focus on the protester.

[4] This question of form versus subject is well explored by Kenneth Clark in *The Nude – A Study of Ideal Art*, London 1956. Each type of subject – each 'genre', as art historians would say – has traditionally been associated with a distinct form or type of picture, though for centuries painters have consciously combined genres, e.g. a nude in landscape, in Giorgione and many an artist since, or a still life in front of a landscape, as in Ben Nicholson who at times uses contrasting idioms for the two elements. Progressive nineteenth-century painters, such as Courbet, challenged the values conventionally attached to the genres by giving 'minor' subjects, such as pictures of country folk, the scale and character of 'major' subjects presenting elevated religious or literary subjects. It might be thought that a painter of today, like Stass, especially one not eager to parade his professional knowledge, would be free of the heritage of conventions that ruled western art for centuries and are found, indeed, in all highly developed art. But. although these conventions cannot constrain him and may not guide him at a conscious level, they are part of his knowledge of art and thus inflect his process of feeding the reality of personal experience into his work.

[5] This use of clear proportional ratios, which goes back to Pythagoras who showed their relationship to the major intervals in music and to cosmic order, as then understood, highlights Stass's feeling for clear and communicative presentation. He often works on square (1 : 1) and 2 : 3 (e.g. 40 x 60 cm or 100 x 150 cm) or 3 : 4 (e.g. 75 x 100 cm) boards or canvases. Where measurements come very close to these ratios, we can assume a variation in a stretched canvas rather than an intended variant. These commanding forms confront him when he begins painting; we receive the finished paintings without ever wondering whether they might have been of other proportions. Deciding the format and size of his surface is just one of an infinity of decisions the painter makes, some consciously, some by instinct, between embarking on and finishing a picture. Occasionally Stass chooses a surprising alternative, as in his early *Still Life with Skull*, which is 3 : 1 and feels very tall. Some of his early landscapes are double squares, giving them a panoramic character.

[6] Stassinos Paraskos, *Mythology of Cyprus*, Nicosia 1981, written in English, was published again as *Aphrodite Cyprus*, London 1988, and reissued by the same publisher in 2000 as *Mythology of Cyprus*. Stass has told me the he is 'illiterate in two

languages' (letter of July 24, 2002), which is clearly not the case. He writes poetry and articles in Greek, his primary language. His English (written as well as spoken) is almost perfect, permitting him some personal usages that add to its expressiveness.

[7] Stass's own words, in his letter of July 24, 2002.

[8] What follows is indebted to Michael Paraskos's booklet, *The Great Wall of Lempa*, Paphos 1999, and to the introduction written for it by Grahame Parry, the painter who, after coming to the Cyprus College of Art for post-graduate work, has served intermittently as its principal's assistant. The information given here comes mostly from those texts. I have visited Lempa and studied the wall on three or four occasions, and I have had some conversation about it with Stass, so that I am in a position to make some observations of my own. No account of Stass's work would be complete without bringing into it some account of the wall as a piece of public, environmental sculpture/ architecture, not least since it reminds us of his role as teacher, and as an artist who is as eager to come out of the studio and work with and for the public, as he is to be in his studio and pursue his art in solitude before offering it to the public.

INDEX OF WORKS